CAMBRIDGE PORTRAITS

FROM LELY
TO HOCKNEY

290

**This book is to be returned on or before
the last date stamped below.**

**LIVERPOOL POLYTECHNIC
LIBRARY SERVICE**

LIBREX

WITHDRAWN

CAMBRIDGE PORTRAITS

FROM LELY TO HOCKNEY

CAMBRIDGE UNIVERSITY PRESS
CAMBRIDGE
LONDON · NEW YORK · MELBOURNE

FOR THE FITZWILLIAM MUSEUM
CAMBRIDGE

Published by the Syndics of the Cambridge University Press
The Pitt Building, Trumpington Street, Cambridge CB2 1RP
Bentley House, 200 Euston Road, London NW1 2DB
32 East 57th Street, New York, NY 10022, USA
296 Beaconsfield Parade, Middle Park, Melbourne 3206, Australia

First published 1978

Printed in Great Britain at the
University Press, Cambridge

Library of Congress cataloguing in publication data
Main entry under title:
Cambridge portraits from Lely to Hockney.
(Fitzwilliam Museum catalogues)
Catalogue of an exhibition.
Includes indexes.
1. Portraits, British–Exhibitions. I. Cambridge. University.
Fitzwilliam Museum. II. Series: Cambridge. University.
Fitzwilliam Museum. Fitzwilliam Museum catalogues.
N7598.C23 704.94′2′094107402659 78–3655
ISBN 0 521 22311 3 hard covers
ISBN 0 521 29353 7 paperback

CONTENTS

PREFACE

This exhibition has been planned not only as the University's principal contribution to the 1978 Cambridge Festival in the visual arts, but also as a grateful salute to the retiring Chairman of the Fitzwilliam Museum Syndicate. During the twelve years of Lord Butler's chairmanship the Museum has been notably enhanced in size and in stature, in ways which affect the whole scale of its operation and, with that, its local, national and international reputation. One of the most consequential of these enhancements is the 1975 Extension, on the top floor of which is our Adeane Gallery designed for special exhibitions. This gallery opened in time for the 1975 Festival with 'Cambridge Plate', to which the University and the Colleges, as well as the City and the National Trust, lent most generously. 'Cambridge Portraits' on show this year in the same place, is conceived as the sequel: but, unlike 'Cambridge Plate', it will be shown only at the Fitzwilliam. We believe that it will be of outstanding interest to Cambridge and its midsummer visitors to sample how fortunate the University and the Colleges have been in their inheritance of fine portraits, and continue to be by discriminate commissions and purchases, and by welcome gifts. In the works chosen for this exhibition the sitters are all members of the University – we include Visitors, Patrons and Benefactors of Colleges.

The first of what was intended to be a series of exhibitions devoted to 'University and College Portraits' was held by the Cambridge Antiquarian Society in the Founder's Building of the Fitzwilliam Museum during three weeks of May and June 1884. The hope expressed by the President of the Society in the exhibition catalogue was that a complete catalogue of all the 'pictures' in the University should eventually be published (there was no thought outside the Museum of pictures other than portraits, nor of portraits other than paintings). Successive periods were to be comprised in annual displays, which were intended to bring out critical comment on the history or the authenticity of the exhibits. The Society inaugurated its series by the period 'terminating with the death of Queen Elizabeth'. Encouraged by the success of this collaboration with the owners and with the Museum, the project was maintained during the following May and June, this time for five weeks, for the period 'terminating with the death of King Charles the Second'. But there was no third exhibition in 1886.

The present exhibition could be said to be ninety-two years overdue. And perhaps it should have attempted to comprise the next period only, terminating with, say, the death of George the Third. But the hope of the Cambridge Antiquarian Society has been largely fulfilled meanwhile by the appearance of J. W. Goodison's *Cambridge Portraits: the University Collection*

in 1955, and by his articles in *The Connoisseur* during the later part of that decade. Those painstaking efforts of scholarship, not to speak of the mere passage of years since the last exhibition, have left the Museum free to resume the project of showing Cambridge and its visitors a selection of University and College Portraits, with a different scope and on a different time scale.

We have chosen to begin not with a sitter of Kneller, but with a sitter of Lely, and to continue to a sitter of Sutherland and a sitter of Hockney. We can do this without overlapping the exhibition of 1885. Thanks to the precisions of Mr Goodison and others – and fortunately we have been able to consult Mr Goodison himself in his retirement – we have scarcely needed to concern ourselves with historical problems of identification or attribution. Happily we have been able to realise, through the outstanding generosity of the owners, a selection governed by the quality and interest of the portraits, rather than by the fame or merit of the sitters; although we rejoice beyond measure that we can show a few of the all too rare examples of high distinction in a Cantabrigian personality being matched by the portrayal.

The Cambridge Antiquarian Society limited itself to paintings. The Fitzwilliam has gone beyond this purview in including miniature portraits, both painted in colours and in silhouette, drawings, medals, busts in bronze or marble, and models or casts of models for sculpture which is oversize to be transported to an exhibition. By restricting our choice chronologically to the centuries when painted portraits were commonly in oils on canvas, we have not had to involve owners and ourselves in discussing how safely to borrow paintings of earlier date which are often on not very well preserved supports of wood.

Condition and appearance have indeed been factors in the selection. The bronze cast from the model for Goscombe John's colossal statue of *The Duke of Devonshire* (69) needed attention to its surface. This conservation work has been done at the Museum. At our Hamilton Kerr Institute, the admirable portrait of *William Mason* by Reynolds (12), which hangs ordinarily in the Hall at Pembroke, has been cleaned so as to reveal its true worth. Some superficial treatment has been given to the early portrait by West, in order to bring it to an exhibitable state. The *Mason* is of 1774. We remembered a letter of 24 May 1787, from Lavinia, Countess Spencer, to her husband, the 2nd Earl, touching a portrait to be painted for his College: 'I can't bear the idea of anybody having a picture by Sir Joshua of you beside myself, and I think that a daub by Gainsborough would do full well as another for them.' But the memory of Lady Spencer's words became wry as we searched the Colleges for some 'daub by Gainsborough' which might remain in a state to do his reputation justice in this company. There seemed little point in moving from its place in Gallery III of the Museum the half-length which he painted of *the Hon. William Fitzwilliam*, our Founder's uncle.

Although we could not gratify the public with a Gainsborough, we saw

more than one fine Romney in the Colleges, including in Emmanuel another full-length than the one we invited from Trinity. Other portrait painters and draughtsmen are particularly well represented in Cambridge collections: John Downman, George Richmond, Hubert von Herkomer, William Rothenstein, William Nicholson, Henry Lamb and Augustus John; and we could have flooded the exhibition with excess of these. There are respectable exercises by minor men; a Vanderbank, an Opie, and numerous drawings by Freeth; but we were sad not to find a Raeburn or a Constable of a Cambridge sitter. The magnificent full-lengths by Sir Thomas Lawrence were too big to accommodate, even if they could have been moved from Trinity. However, the possibilities available to us did not make the choice entirely easy. In several instances, which seem of exceptional interest, we are so fortunate as to be able to show portraits by different artists of the same sitter, among them: the Lely (1) and the Dolci (2) of *Sir John Finch*; the Kneller (4) and the Belle (5) of *Matthew Prior*; the Reynolds (13) and the Romney (14) of *William Frederick, Duke of Gloucester*; the Ouless (20) and the Wyon medal (91) of *Darwin*; the Watts (22) and the Legros plaquette (92) of *Tennyson*; and the Orpen (26) and the Rothenstein drawing (55) of *Montagu Butler*. Some Cambridge men, however, were shy of portraiture: Thomas Gray, whose likeness we show in silhouettes cut by Mapletoft (39, 40), sat only once to a painter; and almost the only likeness extant of his friend our Founder, is the pleasing portrait commissioned by his tutor, Samuel Hallifax, from Wright of Derby (9). Some who sat, or their families and friends, were not ready to believe that the sittings had occasioned a masterpiece. And in this century alone there is evidence that A. C. Benson (29), W. L. Mollison (30), P. C. Vellacott (34) and A. D. Waley (61) more or less vigorously disliked their portraits. Did Matthew Prior dislike the superb Kneller (4), or prefer to it the fashionably accomplished Belle (5)? Did Louis Clarke, who enjoyed sitting to his friend John (54), or, with equal panache to Epstein (71), take kindly to the brilliant observation of him, a few thumbnails broad, by Gunn (36)? As a connoisseur, he surely liked this sketch better than the tamed rendering of the pose and personality in the finished group for the Society of Dilettanti.

Undaunted, occasionally bold, but often too cautious, the Colleges at least persevere in traditional habits of acquiring portraits by commission or by purchase. Others have come to them by gift or by bequest. In recent years Darwin has had commissioned the *Max Rayne* (38) from Graham Sutherland; Trinity, the most active College in commissioning drawings, had the *Piero Sraffa* (62) from Guttuso. T. S. Eliot gave Magdalene his portrait (33) painted by Wyndham Lewis; Sir Edmund Leach gave King's his portrait (63) by Hockney; and a body of subscribers gave to the Zoology Faculty the bronze bust of *Sir James Gray* (72) which they had commissioned from Epstein. Peterhouse took a favourable opportunity to buy the Zoffany of *Edmund Keene* (11). The Fitzwilliam has received, as a gift from its Friends, the Gunn sketch of *Louis Clarke* (36); as well as the Dolci portraits

of *Finch* (2) and of *Baines* (3), with a full grant from the National Art-Collections Fund. The Museum used a small part of its purchase fund from the University to acquire an 'artist's copy' of the bronze medal struck to commemorate the retirement of Professor William Watts from the Chair of Geology at the Imperial College of Science (94). It is to be regretted that the University no longer commissions either such personal medals, nor indeed, following nineteenth-century practice, the installation medals which marked Chancellorships. This method of commemoration, the cost being shared by subscriptions to an edition, would be an attractive alternative to painted, graphic, or even photographic portraiture; and medals uncontaminated by corrosion could outlast all these. Could there not be another Simon, another Dassier, or another Wyon to reveal his talents for our generation and for posterity? The occasional failure could hibernate in a drawer almost as easily as a drawing or photograph.

This may be for the future. Now we are most glad of what we have here on exhibition and most grateful to all the generous lenders: to the Vice-Chancellor, to the other Heads of Houses, and to their College Councils. For detailed information and for other very helpful attentions we thank particularly Mr D. Missen in Christ's, Mr Crosthwait in Darwin, Dr G. D. S. Henderson in Downing, Dr F. H. Stubbings in Emmanuel, Mrs P. Gaskell in Girton, Professor Austin Gresham in Jesus, Mr K. Polack in King's, Mr R. Latham in Magdalene, Mr P. Inskip in Newnham, Dr A. V. Grimstone in Pembroke, Dr D. Watkin in Peterhouse, Mr S. Wildman in Queens', Mr R. T. B. Langhorne in St John's, Dr R. Robson in Trinity; also the Head of the Zoology Department, Dr D. A. Parry; the Deputy Librarian, Mr J. C. T. Oates; and, in the Registry, Mr R. N. Barlow-Poole.

On behalf of the Museum, I thank the Cambridge Festival Association for their valuable contribution to the support of the exhibition, and the Syndics and staff of the University Press for undertaking the publication of the catalogue. Among my own staff, I am particularly grateful to those who have assisted me with the choice of loans, and with the drafting of entries: Duncan Robinson, for the paintings, miniatures, drawings and silhouettes; Graham Pollard for the medals and plaquettes; and Robin Crighton, for the remaining sculpture. The high standard of photography is due to Frank Kenworthy and to the Department of Coins and Medals.

MICHAEL JAFFÉ

LENDERS TO THE EXHIBITION

Christ's College, 1, 20
Clare College, 30
Darwin College, 38
Downing College, 18
Emmanuel College, 7, 16, 32, 52
Fitzwilliam Museum, 2, 3, 6, 9, 19, (26), 28, 29, 36, 40, 43, 44, 45, 46, 47, 48,
 49, 53, 54, 64, 65, 71, 73, 75, 76, 77, 78, 79, 80, 82, 83, 84, 85, 86, 87, 88,
 90, 91, 92, 93, 94
Girton College, 35
Jesus College, 31
King's College, 15, 23, 24, 61, 63
Magdalene College, 8, 33
Newnham College, 25, 68
Pembroke College, 12, 37, 39, 41, 42, 50
Peterhouse, 11, 34
Queens' College, 10, 21, 51
St John's College, 5, 66
Trinity College, 4, 13, 14, 22, 55, 56, 57, 58, 59, 60, 62, 67, 70, 74, 81, 89
University of Cambridge (Old Schools), 17, 69
University of Cambridge (Fitzwilliam Museum), *see* Fitzwilliam Museum
University of Cambridge (University Library), 27
University of Cambridge (Department of Zoology), 72

ABBREVIATIONS

Cambridge Portraits II–IV	J. W. Goodison, '*Cambridge Portraits* II, Later Seventeenth and Early Eighteenth Centuries', 'III, Later Eighteenth and Early Nineteenth Centuries', 'IV, Later Nineteenth and Twentieth Centuries', *The Connoisseur*, vol. 140, 1957, pp. 231–6; vol. 143, 1959, pp. 84–90; vol. 144, 1959, pp. 8–13.
Catalogue III	Fitzwilliam Museum Cambridge. *Catalogue of Paintings*, vol. III. British School, by J. W. Goodison, Cambridge, 1977.
Earp	F. R. Earp, *A Descriptive Catalogue of the Pictures in the Fitzwilliam Museum*, Cambridge, 1902.
Forrer	L. Forrer, *Bibliographical Dictionary of Medallists*, 8 vols., London, 1904–30.
Goodison, 1955	J. W. Goodison, *Catalogue of Cambridge Portraits, I The University Collection*, Cambridge, 1955.
Medallic Illustrations	E. Hawkins, *Medallic Illustrations of the History of Great Britain and Ireland to the death of George II* (ed. A. W. Franks and H. A. Grueber), 2 vols., London (British Museum) 1885.
Principal Pictures	*The Principal Pictures in the Fitzwilliam Museum*, London and Glasgow, 1912. Second edition, enlarged, 1929.
R.A.	Royal Academician (for artists). Royal Academy (for exhibitions).
Venn	J. & J. A. Venn, *Alumni Cantabrigienses, Part I up to 1751* vols. I–IV Cambridge, 1922–1927; J. A. Venn, *Alumni Cantabrigienses Part II 1752–1900*, vols. I–VI Cambridge, 1940–1954.
Winter	C. Winter, *The Fitzwilliam Museum, an Illustrated Survey* Paris, Trianon Press for the Museum, 1958.

I OILS

Sir Peter Lely (1618–1680)

1 *Sir John Finch, F.R.S., F.R.C.P.*

Oils on canvas
62.5 × 54 cm (24⅝ × 21¼ in)
Inscribed with the sitter's name, lower left

The younger brother of Heneage Finch, Lord Chancellor and Earl of Nottingham, John Finch (1626–1682) was admitted to Christ's in 1645. There he met Thomas Baines (see no. 3). The two became inseparable. In 1651 they travelled together to Padua to study medicine. In Italy Finch combined the post of British Consul at Padua with a Chair at the University of Pisa until 1661, when both men returned to England. They became extraordinary Fellows of the Royal College of Physicians and, in 1663, Fellows of the Royal Society. Finch was knighted in 1661. Further diplomatic postings followed, first to Florence and then, in 1672, to Constantinople. When Finch died in 1682 he was buried alongside his lifelong companion in their College Chapel.

Like the pair of Dolci portraits of *Finch* and *Baines*, this Lely belonged to the Earls of Winchilsea and Nottingham at Burley-on-the-Hill, Rutland, until it was sold by order of Major James Hanbury at Christie's, 20 June 1947, lot 61. It was given to Christ's by George F. Roe that year.

LITERATURE: *Cambridge Portraits* II, p. 231, no. 2, repr.

Christ's College

Carlo Dolci (1616–1686)

2 and 3 *Sir John Finch F.R.S., F.R.C.P.* and *Sir Thomas Baines, F.R.S., F.R.C.P.*

Oils on canvas
87.2 × 70.8 cm and 86.2 × 72.4 cm (34⅜ × 27⅞ in and 34 × 28½ in) respectively

(For details of the life of Sir John Finch, see no. 1.)

The portraits were painted in Florence between 1665 and 1670, during Finch's residency there as Minister to the Grand Duke of Tuscany. Thomas

Baines (1622–1681) was admitted to Christ's as a pensioner in 1638. He is shown with works by Aristotle and Plato; a reflection of the fact that both he and Finch were, at Cambridge, pupils of the famous Platonist, Henry More. In addition to the honours he shared with Finch as a physician, Baines was appointed Professor of Music at Gresham College in 1661, a post which he relinquished shortly afterwards to accompany his companion abroad. He received his knighthood in 1672. Baines died in Constantinople in 1681. His body was brought back to England by Finch for interment in their College Chapel.

The portraits remained in the possession of the descendants of the Finch family at Burley-on-the-Hill until 1947, when they were sold (Major James Hanbury sale, Christie's, 20 June 1947, lots 18–19). They were owned subsequently by Sir Thomas Barlow and by S. W. Christie-Miller, from whose estate they were purchased in 1972 by the National Art-Collections Fund for the Fitzwilliam.

EXHIBITED: London, R.A., 'Italian Art 1200–1900', 1930, no. 728 (Baines); *idem.*, 'Works by Holbein and other Masters of the 16th and 17th Centuries', 1950, nos. 297 and 299; Manchester City Art Gallery, 'Art Treasures Centenary', 1957, no. 246 (Baines); London, R.A., 'Italian Art and Britain', 1960, no. 10 (Baines).

LITERATURE: Baldinucci, *Notizie di Professori del Disegno*, VI, 1728, p. 503; Cust & Malloch in *Burlington Magazine*, XXIX, 1916, p. 292, repr.; Hope Nicholson, *The Conway Letters*, 1930, p. 462; W. G. Constable in *Dedalo*, May 1930, pp. 758, 762, repr.; Denys Sutton in *Country Life*, 29 December 1950.

Fitzwilliam Museum (PD. 12 & 13-1972)

Sir Godfrey Kneller (1646–1723)

4 *Matthew Prior* 1700

Oils on canvas
135.6 × 100.3 cm (54¼ × 40⅛ in)
Signed and dated, lower left, 'G. Kneller Eques f./1700'

Matthew Prior (1664–1721), poet and diplomat, became a fellow of St John's in 1688. The Treaty of Utrecht, 1713, was nicknamed 'Matt's Peace', after the part he played in the negotiations. A collector of pictures and prints, he sat, as well as to Kneller, to Rigaud, to Coysevox and to A. S. Belle (see no. 5).

The portrait was engraved in 1728 by J. Faber Jr as in the collection of George Montagu, 2nd Earl of Halifax (d. 1739). Halifax may have inherited

it in 1715 from his uncle, Charles Montagu, a friend of Prior. It belonged subsequently to Frederick Townsend of Honington Hall, who sold it at Christie's, 17 February 1906, lot 137, bt Fairfax Murray. Charles Fairfax · Murray (1849–1919) was a notable connoisseur and *marchand-amateur* who benefited a number of institutions, including the Fitzwilliam Museum (see no. 6). With characteristic generosity, he presented the portrait of Prior anonymously to Trinity in 1908, notwithstanding the sitter's lack of connexion there. In 1912, a second version of the portrait belonged to F. B. Mildmay, M.P., later 1st Lord Mildmay of Flete. An inferior version of the head and shoulders only is in the Victoria and Albert Museum (Dyce Bequest, no. 64).

EXHIBITED: London, National Portrait Gallery, 'Godfrey Kneller', 1971, no. 80.

LITERATURE: Lord Killanin, *Sir Godfrey Kneller and his times, 1646–1723*, London, 1948, plate 51; E. K. Waterhouse, *Painting in Britain, 1530–1790*, Harmondsworth, 1953, p. 99; M. Whinney & O. Millar, *English Art, 1625–1714*, London, 1957, p. 198; D. Piper, *Catalogue of the seventeenth-century portraits in the National Portrait Gallery, 1625–1714*, London, 1963, p. 288. *Cambridge Portraits* II, p. 233, no. 6, repr.

Trinity College

Alexis Simon Belle (1674–1734)

5 *Matthew Prior*

Oils on canvas
145 × 112 cm (57 × 44⅛ in)

(For details of this sitter, see no. 4.)

This portrait was painted in 1713 or 1714, while Prior was Minister Plenipotentiary in Paris. It is said to have been made at the order and expense of Louis XIV, and to show Prior in his court habit. A copy belonging to the Marquess of Northampton at Castle Ashby may be by John van der Vaart, *c.* 1721. Belle's original was either given by Prior to his college, *c.* 1718, or bequeathed.

EXHIBITED: London, Goldsmiths' Hall, 'Treasures of Cambridge', 1959, no. 28.

LITERATURE: *Cambridge Portraits* II, p. 234, no. 10, repr.

St John's College

William Hogarth (1697–1764)

6 *Benjamin Hoadly, M.D., F.R.S.*

Oils on canvas
60.7 × 47.9 cm (23⅞ × 18⅞ in)

Benjamin Hoadly (1706–1757) was a Doctor of Medicine of Cambridge and a Fellow of the Royal Society, and from 1742 to 1745 physician to the royal household. He combined medical with literary practice; his comedy *The Suspicious Husband* was performed by Garrick at Covent Garden in 1747. His penmanship was also employed to help his friend Hogarth in the writing of the *Analysis of Beauty*. Hogarth painted Hoadly's portrait at least three times. Goodison (*Catalogue* III, p. 111) assigns this version to the late 1730s, that is a few years before the portrait dated 1740 (National Gallery of Ireland, no. 398). The bust in the background may be identified as *Isaac Newton*, and compared with the terracotta by Roubiliac at Trinity. Hogarth owned such a bust, probably given to him by the sculptor. A terracotta bust of Newton appeared in the posthumous sale of Mrs Hogarth's collection, 24 April 1790, lot 56.

The portrait appeared in the Smart sale, Foster & Son, London, 16 January 1850, lot 32, bt White; and in the William Benoni White sale, Christie's, 24 May 1879, lot 200, bt Cox. Subsequently it belonged to Joseph Prior of Cambridge (1834–1918), from whom it was bought by Charles Fairfax Murray before 1902. He gave it to the Fitzwilliam in 1908.

EXHIBITED: London, R.A., 'Winter Exhibition', 1908, no. 82; Tate Gallery, 'Hogarth', 1971–2, no. 103.

LITERATURE: *The Masterpieces of Hogarth*, 1911, p. 16, repr.; *Principal Pictures*, 1912, p. 83, repr., 1929, p. 102, repr.; C. R. L. Fletcher and Emery Walker, *Historical Portraits*, III, London, 1919, p. 90, repr.; *Principal Pictures*, 1929, p. 102, repr.; R. B. Beckett, *Hogarth*, London, 1949, repr. plate 81; Goodison, 1955, p. 81, no. 112; *Cambridge Portraits* II, p. 234, no. 14, repr.; Frederick Antal, *Hogarth and his place in European Art*, 1962, repr. plate 39b; Ronald Paulson, *Hogarth, his life, art and times*, 2 vols., 1971, repr. I, plate 159; *Catalogue* III, pp. 111–12, repr. plate 8.

Fitzwilliam Museum (no. 648)

Allan Ramsay (1713–1784)

7 *Anthony Askew, M.D.*

Oils on canvas
124.5 × 101.7 cm (49 × 40 in)
Signed and dated 1750

Anthony Askew (1722–1772) was admitted to Emmanuel as a pensioner in 1739. He was both a classical scholar and a doctor of medicine, who became physician to St Bartholomew's and to Christ's Hospitals, and Registrar of the College of Physicians. He took his M.D. in 1750, the year of the portrait in which he is shown wearing fur-trimmed scarlet. Beside him, the folio open at a page headed 'Hippocrates' alludes to his double interest and to his activity as a book-collector. The portrait was already in the College, *c.* 1790.

LITERATURE: A. Smart, *The Life and Art of Allan Ramsay*, London, 1952, pp. 154, 207; *Cambridge Portraits* II, p. 236, no. 19, repr.; Frank Stubbings, 'Anthony Askew's *Liber Amicorum*', *Transactions of the Cambridge Bibliographical Society*, VI, 1976, pp. 306–22.

Emmanuel College

Thomas Hudson (1701–1779)

8 *Elizabeth, Countess of Portsmouth*

Oils on canvas
124.5 × 99 cm (49 × 39 in)

The Hon. Elizabeth Griffin (1691–1762) married John, 1st Earl of Portsmouth, as his second wife in 1741. She was the elder daughter of James, 2nd Baron Griffin of Braybrooke; and she became coheir to her brother Edward, 3rd and last Baron Griffin of Braybrooke, who died in 1742. Later that century, the hereditary title of Visitor of Magdalene passed with the estates of the Griffin family to Richard Aldworth-Neville, who became Griffin, Lord Braybrooke.

The portrait was acquired by the College during the nineteenth century. Another version belongs to Viscount Lymington at Farleigh House; and a half-length is in the possession of Lord Braybrooke at Mutlow Hall.

LITERATURE: *Cambridge Portraits* II, p. 235, no. 16, repr.

Magdalene College

Joseph Wright, of Derby (1734–1797)

9 *Richard, 7th Viscount Fitzwilliam of Merrion* 1764

Oils on canvas
74.9 × 62.6 cm (29½ × 24½ in)

The Hon. Richard Fitzwilliam (1745–1816), was the eldest son of the 6th Viscount Fitzwilliam of Merrion. He succeeded his father as 7th Viscount in 1776. He was admitted to Trinity Hall as a nobleman fellow-commoner in 1761, and is shown wearing the appropriate gown. The portrait was painted in 1764, the year in which he took his M.A. degree, for Samuel Hallifax, fellow and tutor of Trinity Hall and his private tutor (see no. 46). Three years after the sitter's death, and the foundation of the Fitzwilliam Museum by the terms of his bequest to the University, the portrait was given by his godson, the Rev. Robert Fitzwilliam Hallifax, son of Samuel Hallifax.

EXHIBITED: London, Goldsmiths' Hall, 'Treasures of Cambridge', 1959, no. 1.

LITERATURE: Earp, p. 218, repr.; *Principal Pictures*, 1912 edn., p. 215, repr.; 1929 edn., p. 249, repr.; *Connoisseur*, XLIII, 1915, p. 114, repr.; *Illustrated London News*, CCXI, p. 452, repr.; Goodison, 1955, p. 89, no. 127, repr. plate VX; Winter, frontispiece; Benedict Nicolson, *Joseph Wright of Derby*, 2 vols., London and New York, 1968, I, pp. 26, 31, 68, 197, no. 60, II, plate 49; *Catalogue* III, pp. 292–3, plate 20.

Fitzwilliam Museum (no. 1)

Benjamin West, P.R.A. (1738–1820)

10 *Richard Newcome, Bishop of St Asaph* 1767

Oils on canvas
142.3 × 113.8 cm (56 × 44¾ in)
Signed and dated, lower left, 'Richd Newcome Ld Bpof /St Asaph/B West PINXIT/ 1767'

Richard Newcome was admitted to Queens' as a pensioner in 1718. He held a fellowship there, 1723–34. Bishop of Llandaff 1755–61 and Bishop of St Asaph 1761–9, he owed his preferment in later life to the patronage of the Dukes of Bridgewater, one of whose heirs he took on the Grand Tour in 1743.

The portrait is an important early work by the young West. Its date of acquisition by the College is not known.

Queens' College

Johann Zoffany (1733–1810)

11 *Edmund Keene, D.D., Bishop of Chester* 1768

Oils on canvas
Approx. 140 × 115 cm (55 × 45 in)

Edmund Keene (1715–1781) was admitted to Gonville and Caius as a pensioner in 1730, where he became a scholar, 1730–4, and a fellow, 1736–9. He then became a fellow of Peterhouse, where he was Master 1748–54, and served as Vice-Chancellor, 1749–51. Bishop of Chester, 1752–71 and of Ely, 1771–81.

This excellent original was painted when Keene was Bishop of Chester, in 1768. It was bought by Peterhouse from descendants of the sitter in 1964. Inferior versions of it exist, according to the College records, at Chester and at Ely. A mezzotint after it by Charles Turner, 1812, was exhibited in the recent Zoffany exhibition at the National Portrait Gallery (14 January to 27 March 1977), no. 44, where it was incorrectly stated (catalogue, p. 44), that the whereabouts of the actual portrait were unknown.

Peterhouse

Sir Joshua Reynolds, P.R.A. (1723–1792)

12 *The Rev. William Mason* 1774

Oils on canvas
76 × 63 cm (28¾ × 24½ in)

William Mason (1725–1797) was admitted to St John's; B.A., 1746. He then transferred to Pembroke Hall. There he became M.A. in 1749, and was a fellow 1749–59. Having entered the ministry in 1754, he became, in 1762, Canon and Precentor of York. His publications, which include a number of plays, run to four volumes. His recreations included scientific experiments, painting, gardening, and playing the organ and the pianoforte. In Cambridge, Mason belonged to a talented circle, scholars and litterati, which included Thomas Gray, Horace Walpole and Richard Stonhewer. On 23 June 1774, Mason wrote to Christopher Alderson, 'Stonhewer has made me sit for my picture to Sr. Joshua Reynolds. He has taken a great deal of pains with it and says it is the very best head he ever painted'. Mason paid Reynolds 35 guineas for the portrait, in two equal instalments, the first on 12 May 1774 (recorded in Reynolds's *Ledgers* in the Fitzwilliam Museum). Stonhewer sat to Reynolds a year later (that portrait was last recorded in a sale at Christie's, 15 July 1949, lot 164). Mason must have either given or bequeathed his portrait by Reynolds to Stonhewer, for it was he who bequeathed it, in 1809, to Pembroke.

A copy of the portrait was painted, probably in Reynolds' studio, for Henry Duncombe of Copgrove Hall, near Knaresborough, in 1785. Another copy made by William Staveley, an artist active in York *c.* 1780–1800, has belonged, with a companion portrait of Gray, at least since 1905, to the Dean and Chapter of York. A third copy was purchased at Christie's (22 March 1902, lot 70) by Sir Albert K. Rollitt, who presented it to Hull Corporation. A mezzotint after the portrait was engraved by William Doughty in 1779.

EXHIBITED: York, City Art Gallery, 'A Candidate for Praise', June–July 1973, no. 51.

LITERATURE: Ellis K. Waterhouse, *Reynolds*, London, 1941, p. 64; *Cambridge Portraits* III, p. 85, no. 4, repr.; Bernard Barr & John Ingamells, *A Candidate for Praise*, catalogue of the exhibition in York, 1973, pp. v, 22–73 ff., repr. plate 1.

Pembroke College

13 *H.R.H. Prince William Frederick, later 2nd Duke of Gloucester* 1780

Oils on canvas
136 × 98 cm (53½ × 38½ in)

Prince William Frederick (1776–1834) was admitted to Trinity as a nobleman fellow-commoner in 1787, aged twelve. He was thus the first member of the royal family to be entered at a College of the University. He received the degree of M.A. in 1790. In 1811, he became Chancellor of the University.

This portrait, in 'Van Dyck' dress, was painted for his father, William Henry, 1st Duke of Gloucester, in 1780. In 1788, Reynolds received £105 for the picture, then in the family's possession. It belonged subsequently to the Duke's sister, the Princess Sophia Matilda, who bequeathed it to the College in 1843, through the good offices of Canon Douglas Gordon. Graves and Cronin, *op. cit.*, quote from a letter written by the Canon, dated 22nd October 1898; 'When I went up to Trinity in 1842 I used to see a great deal of the Princess Sophia Matilda, Ranger of Greenwich Park, and as a Freshman full of admiration for my College of which I used to boast. One day the old Princess shewed me the picture of the Duke her brother...and asked me if I thought it would look well in the Hall. On my saying what a boon it would be she very graciously said "You can tell Mr. Whewell that I will leave it to the College through you and I hope you will see this picture placed in a good position". At her death I took it down to Trinity where I was still an undergraduate.' The portrait was engraved by Caroline Watson in 1784, by C. A. Tomkins in 1863 and by H. R. Tobertson in 1884.

EXHIBITED: London, R.A., 1780, no. 167; London, British Institution, 1813, no. 78, and 1843, no. 42, lent by Princess Sophia; London, R.A., 1879, no. 45; London, Grosvenor Gallery, 1884, no. 53.

LITERATURE: A. Graves & W. V. Cronin, *A History of the Works of Sir Joshua Reynolds*, 4 vols., London, 1899–1901; Ellis K. Waterhouse, *Reynolds*, London, 1941, p. 71, no. 167, repr. plate 220; *Cambridge Portraits* III, p. 85, no. 3, repr.

Trinity College

George Romney (1734–1802)

14 *H.R.H. Prince William Frederick, 2nd Duke of Gloucester* 1791
Oils on canvas
236 × 167 cm (93 × 65¾ in)

(For details of the sitter, see no. 13.)

In this portrait, the Duke wears the gown of a nobleman fellow-commoner. The sittings took place between July 1790 and May 1791. The picture was delivered to the College on 15 June 1791, presumably as a gift from the Duke. Romney received £100 with £30 interest on 20 February 1798. It was engraved in stipple by J. Jones in 1793.

LITERATURE: *Cambridge Portraits* III, p. 89, no. 16, repr.

Trinity College

Sir Nathaniel Dance-Holland, R.A. (1734–1811)

15 *Charles Pratt, Viscount Bayham of Bayham Abbey and 1st Earl Camden, P.C., F.R.S.*

Oils on canvas
126 × 100.5 cm (49⅝ × 39½ in)

Charles Pratt (1714–1794) was admitted to King's, a scholar from Eton, in 1731. He became a fellow of his College in 1734. F.R.S., 1742. Called to the Bar in 1738, he was Attorney-General, 1759–62. Lord Chancellor, 1766–70 and Lord President of the Council, 1782–3 and 1784. Baron, 1765; Earl, 1786.

The sitter is shown wearing the Lord Chancellor's gown and wig. The portrait was given to the College by Provost Austen Leigh and A. H. A. Morton in 1880. A version with a hat belongs to Lord Kenyon at Gred-

ington. What is probably another version is at Eton (L. Cust, *Eton College Portraits*, London, 1910, p. 73).

King's College

Gilbert Charles Stuart (1755–1828)

16 *William Bennet, Bishop of Cloyne, D.D., F.S.A.*

Oils on canvas
73.7 × 61 cm (29 × 24 in)

William Bennet (1746–1820) was admitted to Emmanuel, from Harrow, in 1763. He took his M.A. in 1770, having become a fellow in 1769. He served subsequently as Tutor and Proctor. D.D. by incorporation at Dublin in 1790, he was Bishop of Cork and Ross, 1790–4, and Bishop of Cloyne, 1794–1820. An authority on Roman roads in Britain, he was elected F.S.A. in 1790.

In the manuscript catalogue of the College's collection compiled by A. J. Finberg in 1917, and presented to the Fitzwilliam Museum library by his widow in 1954, the portrait is given as 'Artist unknown, probably by Gilbert Charles Stuart'. The suggested attribution seems stylistically valid, and is supported by the artist's period of residence in Ireland, 1787–93. The date of acquisition by the College is not recorded.

LITERATURE: *Cambridge Portraits* III, pp. 86–7, no. 10, repr.

Emmanuel College

John Hoppner, R.A. (1758–1810)

17 *Richard Porson* 1796

Oils on canvas
76.2 × 63.5 cm (30 × 25 in)

Richard Porson (1759–1808) was admitted to Trinity in 1778, and became a fellow in 1782. He was one of the University's most distinguished Grecians, and was elected Regius Professor of Greek in 1792. He is buried in the College Chapel. The Hoppner portrait was given to the University Library in 1833 by Mrs Esther Raine. She had presumably inherited it from her brother, Dr Matthew Raine, headmaster of Charterhouse School and, according to the contemporary writer Pryse Lockhart Gordon, 'the most intimate of Porson's friends, (who) had the greatest influence over him'. Raine had, according to the same source, 'a very fine portrait of him...and

a perfect likeness' (quoted by W. McKay and W. Roberts, *John Hoppner, R.A.*, London, 1909, p. 210). *The Monthly Magazine*, vol. XXVII, 1 April 1809, p. 307, advertises a proposal by Porson's friends 'to have engraved a print, from a portrait of him by Hoppner, now in the possession of Dr. Raine'. This is presumably the stipple and line-engraving by W. Sharp, published in 1810, the first of four engravings to be made after the portrait. A painted replica by J. Brooke of the original belongs to Trinity.

EXHIBITED: London, Goldsmiths' Hall, 'Treasures of Cambridge', 1959, no. 35.

LITERATURE: A. C. Benson, *Fasti Etonenses*, 1899, p. 236, repr.; C. R. L. Fletcher & Emery Walker, *Historical Portraits*, vol. IV, London, 1919, repr. facing p. 34; Goodison, 1955, pp. 29–30, no. 33, repr. plate XV; *Cambridge Portraits* III, p. 89, no. 17, repr.

University of Cambridge (Old Schools)

George Richmond (1809–1896)

18 *Thomas Worsley*

Oils on canvas
127 × 101 cm (50 × 40 in)

Thomas Worsley (1777–1885) was admitted to Trinity as a pensioner in 1815. He took his M.A. and migrated to Downing in 1824. Fellow and tutor of Downing 1824–36, Master from 1836 until his death. Vice-Chancellor, 1837–8.

In this case the painter as well as the sitter has associations both with Downing and with the University. He was awarded an hon. LL.D in 1890. His grandson, Admiral Sir Herbert Richmond, was Master of Downing, 1936–46. Richmond was commissioned to paint a number of portraits in Cambridge; among them *William Wilberforce* of 1834 and *George Augustus Selwyn, Bishop of Lichfield* of 1855, both for St John's, and *Helen Gladstone* for Newnham. Although the Worsley is not dated, it may be assumed from the apparent age of the sitter, to have been painted soon after he became Master, c. 1840.

Downing College

William Holman Hunt, O.M. (1827–1910)

19 *Cyril Benoni Holman Hunt* 1880

Oils on canvas
60.9 × 50.8 cm (24 × 20 in)
Signed with monogram and dated, lower left, 'WHH 1880'

Cyril Benoni Holman Hunt (1866–1934), the eldest child of the painter, was admitted to St John's as a pensioner in 1885. He spent his life subsequently in the Colonial Service in Burma and Malaya. Hunt began a first portrait of his son in September 1873 and finished it in 1875, before he left for his third visit to Palestine. He began this portrait after his return to England in 1878. He finished the likeness a year later, and the whole picture in 1880. The frame is the one designed for it by him. It was bequeathed to the Fitzwilliam by the sitter in 1934.

EXHIBITED: London, Grosvenor Gallery, 'Summer Exhibition', 1880, no. 89; Bradford, Cartwright Memorial Hall, 'Exhibition of Fine Arts', 1904; Liverpool, Walker Art Gallery, 'The Art of William Holman Hunt', 1907, no. 20; Glasgow, Corporation Art Gallery and Museum, 'Pictures and Drawings by William Holman Hunt', 1907, no. 4; Bridport, Dorset, Corporation Museum, on loan 1932–4; Birmingham, City Museum and Art Gallery, on loan 1935–59; Liverpool, Walker Art Gallery and London, Victoria and Albert Museum, 'William Holman Hunt', 1969, no. 54; Tokyo, National Museum of Western Art, 'English Portraits', 1975, no. 55.

LITERATURE: W. Holman Hunt, *Pre-Raphaelitism and the Pre-Raphaelite Brotherhood*, 2nd edn., London, 1913, II, plate 272, repr.; Goodison, 1955, p. 134, no. 236; *Cambridge Portraits* III, p. 10, no. 9, repr.; *Catalogue* III, 1977, pp. 126–8, plate 46.

Fitzwilliam Museum (no. 1760)

Walter William Ouless, R.A. (1848–1933)

20 *Charles Robert Darwin, F.R.S.* 1883

Oils on canvas
65 × 54.5 cm (25½ × 21½ in)
Signed and dated, 'W. W. Ouless 1883'

Charles Darwin (1809–1882), the famous naturalist, was admitted to Christ's as a pensioner in 1827; M.A., 1837; F.R.S., 1834, and Medal of the Royal Society, 1853; Wollaston Medal 1859, followed by a succession of international academic honours.

The date of acquisition of the portrait by the College is not known. It is a replica painted by Ouless of his original of 1875 belonging to the Darwin family. For the medal of Darwin by Wyon, see no. 91.

Christ's College

Sir Hubert von Herkomer, R.A. (1849–1914)

21 *George Phillips, D.D.* 1885

Oils on canvas
73.5 × 61 cm (29 × 24 in)

George Phillips (1804–1892) was admitted to Queens' as a pensioner in 1825. He became a scholar, 1827; and a fellow, 1831–46. President of Queens' from 1857 to 1892, he served as Vice-Chancellor, 1861–2.

Herkomer painted a number of successful portraits in Cambridge, including *Montagu Butler*, Master of Trinity, in 1888. Praised by A. L. Baldry, *op. cit.*, for his 'intimate sympathy with the pathos of rugged and toilworn old age', he outlined in a lecture to the Royal Academy his aims in portraiture;

To get merely the picturesque aspect of the sitter is certainly to satisfy the artistic craving of the painter's nature; but to get this at the expense of the likeness or interpretation of the man is not to satisfy those who are to possess the portrait, and who commission you to do it. On the other hand, to leave out that very quality which makes the work live through centuries as a work of art is to deprive the artist of his first right. It is the combination of the two qualities that constitutes the successful work, and satisfies not only the painter's hopes of posthumous fame, but the man who pays for the picture. (Baldry, *op. cit.*, p. 58.)

LITERATURE: A. L. Baldry, *Hubert von Herkomer, R.A.*, London, 1901.

Queens' College

George Frederic Watts, O.M., R.A. (1817–1904)

22 *Alfred, 1st Baron Tennyson, D.C.L.* 1890

Oils on canvas
63.5 × 51 cm (25 × 20 in)
Signed and dated, 'G. F. Watts 1890'

Alfred, Lord Tennyson (1809–1892) was admitted to Trinity as a pensioner in 1827. He won the Chancellor's Medal for English verse in 1829: but his Cambridge career was cut short by his father's illness. He became Poet Laureate in 1850, and an honorary fellow of his College in 1869.

The initiative for the portrait came from the College. Watts was approached by Tennyson; and the sittings took place at Tennyson's house in the Isle of Wight in May 1890, the year in which the poet presented the portrait to the College. A second version, painted at the same time, but showing the sitter in peer's robes rather than in the scarlet gown of a D.C.L. (Oxon), is at Adelaide, South Australia. For the bronze plaque of Tennyson by Legros, see no. 92.

LITERATURE: *Cambridge Portraits* IV, p. 11, no. 12, repr.

Trinity College

Charles Wellington Furse, A.R.A. (1868–1904)

23 *Frederick Whitting*

Oils on canvas
90 × 70 cm (35½ × 27½ in)

Frederick Whitting (1854–1911) was admitted to King's, a scholar from Eton, in 1854. He took the Browne Medal that year, and was elected a fellow in 1857; M.A., 1861. A private tutor at Eton, 1858–64, he returned to King's where he was Bursar, 1869–92, and Vice-Provost, 1889–1909. He served as Secretary of the Financial Board, 1883–1904.

The portrait was given to the College by non-resident members in 1891.

King's College

Ignazio Zuloaga (y Zabalet) (1870–1945)

24 *Oscar Browning* 1900

Oils on canvas
128.3 × 95.2 cm (50½ × 37½ in)

Oscar Browning (1837–1923) was admitted to King's, a scholar from Eton, in 1856. He was President of the Cambridge Union Society in 1859. He took his M.A. in 1863, having become a fellow in 1859. He returned to Cambridge in 1875 after a controversial spell as Assistant Master at Eton. University Lecturer in History, 1883–1909. Tutor of King's, 1892. A pioneer in education, he helped to establish the Cambridge University Day Training College; and he became its first Principal, 1891–1909. One of the founders of the *Cambridge Review*, Browning was active in politics, as an exponent of Gladstonian liberalism; in drama, as President of the Footlights Club; and in the social life of Cambridge. A clever conversationalist he entertained

ambitiously, 'and showed kindness to innumerable young men'. (Venn, quoting Lowes Dickinson, *Cambridge Review*, 20 May 1927.) He died in Rome.

The portrait, in which Browning is shown wearing in his left lapel the button of an Officier de l'Instruction Publique, was painted in 1900. It was given to the College by Francis, 5th Baron Latymer, in 1909.

King's College

Augustus Edwin John, O.M., R.A. (1878–1961)

25 *Jane Ellen Harrison* 1909

Oils on canvas
62.2 × 75.2 cm (24½ × 29⅝ in)

This portrait of Jane Ellen Harrison (1850–1928), fellow of Newnham and classical scholar, was given to the College by her friends in 1909. Painted in the summer of that year, it is the earliest portrait by John in a Cambridge collection. The *George Bernard Shaw* in the Fitzwilliam (no. 1071) was painted in 1915, and the *Thomas Hardy* there (no. 1116) is dated 1923. Among the large number of drawings by John in the Museum, there are several portraits, including a red chalk study of *Sir Hugh Walpole* (1884–1941) (no. 2516), and three of *Louis Clarke* (PD. 168-1961, PD. 28 & 29-1969; see no. 54), two being studies for the portrait in oils which belongs to Trinity Hall.

EXHIBITED: London, R.A., 'Works by Augustus John', 1954, no. 348; London, Goldsmiths' Hall, 'Treasures of Cambridge', 1959, no. 37.

LITERATURE: *Cambridge Portraits* IV, p. 12, no. 20, repr.

Newnham College

Sir William Newenham Montague Orpen (1878–1931)

26 *Henry Montagu Butler, D.D.*

Oils on canvas
102 × 86.5 cm (40 × 34 in)
Signed, lower right, 'ORPEN'

Montagu Butler (1883–1918) was admitted to Trinity as a pensioner in 1850. He became a scholar in 1853, taking the Browne Medal that year and in 1854, and the Porson Prize in 1855. In 1855 also he was President of the Cambridge

Union Society. He became Tutor of the College, 1855–9. A distinguished career in the church followed his ordination in 1859. He was Head Master of Harrow School, 1860–5, and Master of Trinity, 1886–1918. An ardent supporter of the University Extension scheme and of women's education, he was for some years a member of the Council of Girton, and he lent his support to the proposals of the Syndicate in favour of admitting women to the titles of degrees, 1897.

Another version of the portrait hangs in Trinity, given by subscribers in 1911. This one has been on loan to the Fitzwilliam since 1931. Another portrait of Dr Butler, by H. von Herkomer, belongs to Trinity; as does the drawing of him by William Rothenstein (no. 55 in this exhibition).

Lent by the heirs of Dr Butler

John Singer Sargent, R.A. (1856–1925)

27 *Francis Henry John Jenkinson* 1915

Oils on canvas
91.1 × 71.1 cm (35$\frac{7}{8}$ × 28 in)
Signed, upper left, 'John S. Sargent', and dated, upper right, '1915'

F. H. J. Jenkinson (1853–1923) was admitted to Trinity in 1872. He became a scholar in the following year, took his B.A. in 1876, and was elected a fellow in 1878. Classical scholar, entomologist and antiquary, he was University Librarian from 1889 to 1923.

The portrait was presented to the University by a group of subscribers who commissioned it to commemorate Jenkinson's twenty-fifth year as University Librarian. It was deposited in the Fitzwilliam in 1916, where it remained until it was transferred to the University Library in 1935.

EXHIBITED: London, R.A., 1915, no. 56; Edinburgh, Royal Scottish Academy, 1916, no. 301; London, R.A., 'Works by the late John S. Sargent, R.A.', Winter 1926, no. 344; Royal Glasgow Institution of Fine Arts, 1937, no. 93.

LITERATURE: Goodison 1955, p. 46, no. 53, repr. plate XXIX; *Cambridge Portraits* III, p. 11, no. 14, repr.

University of Cambridge (University Library)

Glyn Warren Philpot (1884–1937)

28 *Siegfried Sassoon, C.B.E., M.C.* 1917

Oils on canvas
61 × 50.8 cm (24 × 20 in)

Siegfried Sassoon (1886–1967), poet and prose writer, was made an honorary fellow of Clare in 1953; M.C., 1916; C.B.E., 1951. The portrait was painted in London during the summer of 1917, apparently at the suggestion of Robert Ross. The pose recalls that of *A Young Breton* exhibited by Philpot at the Royal Academy in 1917 (Tate Gallery, no. 3218). Sassoon, who regarded it as 'an ideal "Posterity portrait"', lent the picture to the Fitzwilliam in 1918, and gave it in 1924.

EXHIBITED: London, Royal Watercolour Society's Galleries, 'Fifty Years Ago', 1965, no. 41; Cambridge, University Library, 'Siegfried Sassoon', 1968; London, Imperial War Museum, 'Poets of the First World War', 1974–5; Cambridge, Fitzwilliam Museum, 'Modern Literary Manuscripts from King's College, Cambridge. An Exhibition in memory of A. N. L. Munby', June–July 1976, no. 35.

LITERATURE: Siegfried Sassoon, *Siegfried's Journey, 1916–20*, London, 1945, pp. 49–51, repr. as frontispiece; Goodison 1955, p. 141, no. 254; *Catalogue* III, p. 193, repr. plate 61.

Fitzwilliam Museum (no. 1121)

Sir William Newzam Prior Nicholson (1872–1949)

29 *Arthur Christopher Benson, C.V.O., LL.D.* 1924

Oils on wood
56.9 × 66.7 cm (22$\frac{3}{8}$ × 26$\frac{1}{4}$ in)

A. C. Benson (1862–1925), author and man of letters, was admitted to King's as a scholar in 1881. Assistant Master at Eton, 1885–1903, and fellow of Magdalene, 1904–15, he became Master of Magdalene in 1915. Nicholson began a portrait of him in 1917, which remained unfinished. This one, painted as a gift to the sitter from Madame de Nottbeck, was completed in three days during May 1924. Benson revealed in his *Diary* that he was not too pleased with the result. He gave it the same year to the Fitzwilliam.

LITERATURE: *Principal Pictures*, 1929, p. 142; Robert Nichols, *William Nicholson*, London, 1948, plate 30; Goodison, 1955, p. 30, no. 222, plate xxxii; *Catalogue* III, 1977, pp. 184–5, plate 54.

Fitzwilliam Museum (no. 1138)

Henry Lamb (1885–1960)

30 *William Loudon Mollison, M.A., LL.D.* 1925–6

Oils on canvas
67.6 × 54.6 cm (26⅝ × 21½ in)

W. L. Mollison (1851–1929), mathematician and classical scholar, was Master of Clare, 1915–29. The portrait is presumably the one paid for by a joint subscription of thirty-one fellows and others in 1926. The sitter disliked the portrait, which he would not allow to be hung in College. As a result, a second portrait was commissioned, this time by Hugh Buss, who finished it from a photograph after the sitter's death.

LITERATURE: reproduced as the frontispiece of the *Clare Association Annual*, 1926.

Clare College

Sir Gerald Kelly, P.R.A. (1879–1972)

31 *Charles Whibley* 1925–6

Oils on canvas
77.5 × 70 cm (30½ × 27½ in)

Charles Whibley (1859–1930) was admitted to Jesus as a pensioner in 1879. Author and journalist, associated with the *Pall Mall Gazette* and *Blackwood's Magazine*, he was an honorary fellow of his College, 1912–30.

The portrait was given to the College by the artist in 1955, from a collection by Sir Frederick MacMillan. There is another portrait by Kelly in a Cambridge college; *Henry Gordon Comber* of 1929, in Pembroke.

EXHIBITED: London, R.A., 1926, no. 91.

Jesus College

William Roberts (b. 1895)

32 *Richard McGillivray Dawkins, F.B.A.* 1939–40

Oils on canvas
43 × 33 cm (17 × 13 in)

Richard McGillivray Dawkins (1871–1955) was admitted to Emmanuel as a pensioner in 1898. He became a scholar the following year, Craven Student

in 1902, and a fellow in 1904. Director of the British School of Archaeology, Athens, 1906–14 and Professor of Byzantine and Modern Greek at Oxford, 1920–39. Fellow of Exeter College, Oxford. Honorary Fellow of Emmanuel, 1922.

The portrait was painted 1939–40, when the sitter was 68. It was given to the College in June 1964 by Professor Nevill Coghill of Exeter and Merton Colleges, Oxford.

Emmanuel College

Percy Wyndham Lewis (1882–1957)

33 *Thomas Stearns Eliot, O.M.* 1949

Oils on canvas
55.2 × 86.3 cm (21¾ × 34 in)
Signed and dated, 'Wyndham Lewis 1949'

Poet, critic and man-of-letters, T. S. Eliot (1888–1965) became an honorary fellow of Magdalene in 1939. He was painted first by Wyndham Lewis in 1938. The portrait of that date is now in the Durban Municipal Art Gallery, South Africa, and a study for it in oils is at Eliot House, Harvard University, Cambridge, Mass. Numerous drawings of Eliot by Wyndham Lewis survive; one for the Magdalene portrait is mentioned by Handley Read as in the collection of Mr E. J. N. Bramall. In the introduction to the catalogue of 'Wyndham Lewis and Vorticism' at the Tate Gallery, 1956, Wyndham Lewis recorded 'my last picture, before blindness, was the portrait of T. S. Eliot, now in Magdalene College, Cambridge. Already, while painting this last, I had to stand close to the sitter, and there was a strict limit to what I could do'. Even so, he worked on the portrait 'till midnight daily' until 4 May, the day before the opening of the Redfern Gallery show in which it was exhibited (letter to Charles Handley Read, 6 May 1949, now in the Department of Rare Books, Cornell University, quoted by Michel, *op. cit.*, p. 158, note 21). Exactly a year later, 10 May 1951, Wyndham Lewis announced his loss of sight in the last of a series of art reviews he contributed to *The Listener*. The portrait was presented to the College by the sitter.

EXHIBITED: London, Redfern Gallery, 'Wyndham Lewis', May 1949, no. 125; London, Tate Gallery, 'Wyndham Lewis and Vorticism', 1956, no. 155; Cambridge, Fitzwilliam Museum, 'Modern Literary Manuscripts from King's College, Cambridge. An Exhibition in memory of A. N. L. Munby', June–July 1976, no. 9.

LITERATURE: *Time*, vol. 53, 30 May 1949, p. 60 (illus.); C. Handley Read, *The Art of Wyndham Lewis*, London, 1957, pp. 29, 47, 75, 82, repr. in colour,

plate B; W. Michel, *Wyndham Lewis*, London, 1971, pp. 144–5, 345, repr. plate 149.

Magdalene College

Ruskin Spear, R.A. (b. 1911)

34 *Paul Cairn Vellacott, C.B.E.* 1949

Oils on canvas
75 × 62 cm (29½ × 24½ in)

P. C. Vellacott (1891–1954), historian, was admitted to Peterhouse as a scholar in 1910. After distinguished war service he returned to Cambridge as a fellow of his College, 1919, and was Tutor and History lecturer, 1920–34. Head Master of Harrow, 1934–9. Master of Peterhouse, 1939–54.

Ruskin Spear has painted a number of portraits in Cambridge, among them *Lord Adrian* for Trinity, *Miss Ruth Cohen* for Newnham, *the Most Reverend, and Rt. Hon. Arthur Michael Ramsey*, former Archbishop of Canterbury, for Magdalene, and *Sir Herbert Butterfield*, Vellacott's successor as Master of Peterhouse. The portrait of Vellacott was commissioned by the College in February 1949. It was disliked by the sitter and has remained, among his former colleagues, a controversial picture.

Peterhouse

Sir Stanley Spencer, R.A. (1891–1959)

35 *Mary Lucy Cartwright, F.R.S., Sc.D.* 1958

Oils on canvas
76 × 49.5 cm (30 × 19½ in)

Dame Mary Cartwright (b. 1900) was admitted to St Hugh's, Oxford, in 1919. She became a fellow of Girton, 1934–9, University Lecturer in Mathematics, 1935–59, and Reader in the Theory of Functions, 1959–68. Mistress of Girton, 1949–68. D.B.E., 1969.

The portrait was commissioned by the College, with the full approval of the sitter. Dame Mary's sister had been a pupil at the Ruskin School in Oxford, where Gilbert Spencer taught, and was a family friend of his wife, née Hilda Bradshaw. Shortly before undertaking this portrait, Stanley Spencer drew in pencil the former Bursar of Girton, Mrs H. Holland. (That drawing now belongs to the College, bequeathed by the sitter.) The painting of Dame Mary was done in her room in Girton, with the background taken

from a different standpoint in the same room, looking out of the window into the College garden. Spencer stayed in College, with interruptions, 7–11 July and 28 July–1 August 1958. On 3 August, he wrote to thank the Mistress, reporting that 'Yesterday I was on my pitch in the Church yard at 7–10 and it was very cold'. Their correspondence continued; on 6 November 1958, Spencer wrote to thank Dame Mary for photographs she had taken of him at work on the portrait. The letter, now in Girton Library, contains a sketch in ball-point pen for a *Visitation*, together with the confidence that 'I am having a muddling time...fiddling about with composition drawings that won't come right'.

EXHIBITED: London, Goldsmiths' Hall, 'Treasures of Cambridge', 1959, no. 42; Cambridge, Fitzwilliam Museum, 'Stanley Spencer, R.A.', 1976–7 (*hors de catalogue*).

Girton College

Sir James Gunn, R.A. (1893–1964)

36 *Louis Colville Gray Clarke, LL.D.* 1959

Oils on canvas, mounted on millboard
30.7 × 28.9 cm (12⅛ × 11⅜ in)
Inscribed, *verso*, 'LOUIS CLARKE 1959/FOR/DILETTANTI'

Louis Clarke (1881–1960), archaeologist, anthropologist and connoisseur, was a fellow of Trinity Hall, Curator of the University Museum of Archaeology and Ethnology, 1922–37, and Director of the Fitzwilliam Museum, 1937–46. Hon. LL.D., Cambridge, 1959. To these distinctions may be added Dr Clarke's record as a sitter. In addition to this portrait, he sat both to de Laszlo and to Augustus John (see no. 54), who became a personal friend; and he was sculpted in bronze by Jacob Epstein (no. 71).

As the inscription on the back shows, this is a sketch for the conversation piece of fifteen members of the Society of Dilettanti painted by Sir James Gunn between 1954 and 1959, and exhibited at the Royal Academy in 1959 (no. 376; *The Royal Academy Illustrated*, 1959, p. 63). Another study of Dr Clarke is in the possession of the Earl Spencer at Althorp Park, Northamptonshire. This one, which had remained in the painter's studio, was with Thomas Agnew & Sons Ltd, from whom it was bought by the Friends of the Fitzwilliam for the Museum in 1975.

LITERATURE: *Catalogue III*, p. 97.

Fitzwilliam Museum (PD. 120-1975)

Allan Gwynne-Jones, R.A. (b. 1892)

37 *Richard Austen Butler, later Baron Butler of Saffron Walden, K.G., P.C., C.H., F.R.S.L.* 1964

Oils on canvas
87 × 70 cm (34¼ × 27½ in)
Signed and dated, 'AGJ-1964/Aug–Sept. Foreign Office'

R. A. Butler (b. 1902) was admitted to Pembroke in 1921. He was President of the Cambridge Union Society, 1924, and a fellow of Corpus Christi, 1925–9; honorary fellow of Pembroke, 1941. M.P. for Saffron Walden from 1929 to 1965. He held office as Minister of Education, 1941–5, and of Labour 1945; as Chancellor of the Exchequer, 1951–5; Lord Privy Seal, 1955–9; Leader of the House of Commons, 1955–61; Home Secretary, 1957–62; First Secretary of State, Deputy Prime Minister and Minister in Charge of Central African Office, 1962–3; and Secretary of State for Foreign Affairs, 1963–4. In 1965 he was created a life peer, and he became Master of Trinity. For twelve years he has served, among many other noble causes, as Chairman of the Fitzwilliam Museum Syndicate. He remains a fellow of Trinity, as well as an honorary fellow of Pembroke.

The portrait was commissioned by the College. Lord Butler chose the artist and had a replica of the portrait painted by Gwynne-Jones for himself.

EXHIBITED: London, R.A., 1965, no. 167.

Pembroke College

Graham Sutherland, O.M. (b. 1903)

38 *Lord Rayne of Prince's Meadows* 1968–9

Oils on canvas
182.2 × 109.9 cm (71¾ × 43¼ in)
Signed, dated and inscribed, *verso*, 'Portrait of/M.R./G.S. 1968–9'

Lord Rayne (b. 1918), financier, has been Chairman of London Merchant Securities Ltd, since 1960. He has been Chairman of the National Theatre Board since 1971, and of the London Festival Ballet Trust, 1967–75. He has been Founder Patron of the Rayne Foundation, since 1962, and is an outstanding benefactor of education, of medicine and of the arts. He became an honorary fellow of Darwin in 1966.

The portrait was commissioned to hang in the College Hall. Sutherland painted a more intimate version for the sitter, which is signed and dated 1967–70.

EXHIBITED: London, National Portrait Gallery, 'Portraits by Graham Sutherland', 1977, no. 85, repr. in colour in the catalogue, p. 27.

Darwin College

II DRAWINGS, MINIATURES AND SILHOUETTES

The Rev. Francis Mapletoft (1730–1807)

39 *Thomas Gray, LL.B.*

Silhouette, black pigment on card
9.5 × 6.3 cm (3¾ × 2½ in)

Thomas Gray (1716–1771), poet, classical scholar and musician, was admitted to Peterhouse as a pensioner in 1734. He became a scholar in the same year and took an LL.B. in 1744. He migrated to Pembroke, 1756–7. Mapletoft was elected a fellow of Pembroke in 1754 and was a friend of Gray. Another, identical, silhouette head of Gray by Mapletoft is at Pembroke and a third, white on black, is exhibited here, no. 40. All three likenesses were taken 1761–5, and are thus contemporary with Lord Fitzwilliam's residence as an undergraduate.

LITERATURE: Paget Toynbee and Leonard Whibley (ed.), *Correspondence of Thomas Gray*, London, 1935, II, p. xxxiii, repr. facing p. 689; J. W. Goodison, 'A Silhouette of Thomas Gray by the Rev. Francis Mapletoft', *Apollo*, XLVII, 1948, pp. 66–7.

Pembroke College

40 *Thomas Gray, LL.B.* 1765

White paper cut out and mounted on black card, with traces of pencil visible around the outline
9.2 × 7 cm (3⅝ × 2¾ in)
Inscribed on the back, 'Profile of Mr Gray/drawn by Mr Mapletoft/in 1765 and given by/Mr Gray to Mr Fitzwilliam/in 1766'

As the inscription reveals, this likeness of Gray was given to Fitzwilliam two years after he graduated. He kept it, presumably as a memento of his friendship in Cambridge with the poet, whose interest in music he shared.

Fitzwilliam Museum (Founder's Bequest) (no. 3932)

41 *The Rev. William Mason*

Silhouette, black pigment on card
9.5 × 6.3 cm ($3\frac{3}{4} \times 2\frac{1}{2}$ in)

(For details of the sitter, see no. 12.)

EXHIBITED: York Art Gallery, 'A Candidate for Praise', 1973, no. 48.

Pembroke College

The Rev. William Mason (1725–1797)

42 *Thomas Gray, LL.B.*

Etching
11.1 × 9.5 cm ($4\frac{3}{8} \times 3\frac{3}{4}$ in)
Inscribed below, 'Mr Gray/W. Mason fecit sibi et amicis'

(For details of the sitter, see nos. 39, 40, with which this is mounted.)

Gray was shy of portraiture; apart from the portrait of him as a boy which was given to the Fitzwilliam Museum in 1858 and has been on loan to Pembroke since 1970 (no. 8; *Catalogue* III, pp. 195–6 repr. plate 6, attributed to Arthur Pond), he sat only once to have his picture painted. That was at the request of Walpole, who commissioned J. G. Eccardt to paint a series of contemporary portraits in imitation of old masters. Eccardt used van Dyck's portrait of the musician Liberti as the basis for his of Gray, who is shown holding his *Ode on a distant Prospect of Eton College*, first published in 1747. Painted in 1848, this 'fancy picture' is now in the National Portrait Gallery, London, and a copy of it is at Pembroke. In Cambridge, however, Gray's likeness was captured by his two friends, the amateurs, Mason and Mapletoft. Their efforts provided the basis for Benjamin Wilson's posthumous portrait of Gray of 1772, which was bequeathed to Pembroke by Richard Stonhewer in 1809. Mason, whom Gray nicknamed 'Old Scroddles', became one of the poet's executors. He inherited all Gray's books, manuscripts and papers from which he compiled his *Memoirs of Gray*, 1775, the model taken by Boswell for his far better known *Life of Johnson* some years later. The plate for this etching is mentioned by Gray in a letter to Brown, 23 October 1760.

EXHIBITED: York Art Gallery, 'A Candidate for Praise', no. 54.

Pembroke College

John Downman, A.R.A. (1750–1824)

43 *Henry Simpson Bridgeman* 1777

Black and white chalk, stump and pink wash
23.5 × 18.7 cm ($9\frac{1}{4}$ × $7\frac{3}{8}$ in)
Inscribed in ink on the mount, 'Mr Bridgeman Fellow Commoner of
Trinity Coll 1777/eldest son of Sir Henry Bridgeman Bart/whose untimely
death was much lamented./I also drew his two brothers and two sisters'

Henry Simpson Bridgeman (1757–82) was admitted to Trinity in 1775. He
sat as M.P. for Wigan, 1780–2.

This and the following drawing by Downman date from his stay in Cam-
bridge, 1777–8. They are 'first studies' or preliminary drawings for por-
traits, mounted by the artist in albums with notes in his hand below each,
giving the name of the sitter, the date of the drawings and occasionally
other remarks. Downman arranged his albums in five series and most, if
not all, of them belonged after his death to his daughter, Isabella Chloe
Downman, later Mrs Benjamin. Some time before 1825, she sold series II,
III and IV to the Hon. George Neville, later Neville–Grenville, Dean of
Windsor, of Butleigh Court, Glastonbury. They passed by descent to Lady
Longmore, from whom the complete second series of drawings, five volumes
of mainly Cambridge subjects, were brought for the Museum in 1936 by
two anonymous Friends of the Fitzwilliam and the National Art-Collections
Fund.

LITERATURE: E. Croft-Murray, 'John Downman's Original First Studies
of Distinguished Persons', *British Museum Quarterly*, XIV, no. 3, 1939–40,
pp. 60–6; Goodison, 1955, p. 96, no. 143.

Fitzwilliam Museum (no. 1829)

44 *George John Spencer, Viscount Althorp, K.G., F.R.S.*

1777

Black, red and white chalk, stump, pink wash
22.8 × 19 cm ($9 × 7\frac{1}{2}$ in)
Inscribed in ink on the mount, 'George John Spencer, Viscount Althorp
at —— College 1777/only son of Earl Spencer/I painted two of this.'

George John Spencer (1758–1834), later renowned as a bibliophile, was
admitted to Trinity in 1776. He took his M.A. in 1778. He became F.R.S. in
1780. He succeeded his father as 2nd Earl Spencer, 1783. Lord Privy Seal,
1794; First Lord of the Admiralty 1794–1801; K.G. 1799; Home Secretary,
1806–7.

EXHIBITED: London, Goldsmiths' Hall, 'Treasures of Cambridge', 1959, no. 89.

LITERATURE: Goodison, 1955, p. 100, no. 155.

Fitzwilliam Museum (no. 1832)

Richard Cosway, R.A. (1742–1821)

45 *Captain the Hon. Edmund Phipps* 1788

Watercolour on ivory
Oval, 5.4 × 4.5 cm ($2\frac{1}{8} \times 1\frac{3}{4}$ in)
Signed and dated on a piece of paper pasted to the back of the miniature, 'R: dus Cosway/R.A./Primarius Pictor/Serenissimi Walliae/Principis/ Pinxit/1788'
Inscribed around the rim of the case with the names of the sitter and of the artist

The Hon. Edmund Phipps (1760–1837) was admitted to St John's as a pensioner in 1778. A professional soldier, he served in Jamaica, 1780–1, and became Captain of the 93rd Foot in 1782. Lieut. and Captain, 1st Foot Guards, 1784, followed by a succession of other appointments. General, 1819. M.P. for Scarborough, 1794–1818 and 1820–32.

Sold at Sotheby's, 20 November 1945, lot 44; Robert H. Rockliff sale, Sotheby's, 11 November 1947, lot. 101 (repr.); Louis C. G. Clarke, by whom bequeathed to the Museum in 1960.

Fitzwilliam Museum (PD. 190-1961)

Henry Edridge, A.R.A. (1769–1821)

46 *Samuel Hallifax, Bishop of Gloucester, D.D., LL.D.*

Watercolour on ivory
Oval, 5.3 × 4.4 cm ($2\frac{1}{2} \times 2\frac{1}{16}$ in)

Samuel Hallifax (1733–90) was admitted to Jesus as a sizar in 1749. He became a scholar, and took the Chancellor's Medal in 1754. He was a fellow first of Jesus, 1756–60, then of Trinity Hall, 1760–75. There he was private tutor to the Lord Fitzwilliam, who founded the Museum; and he commissioned the portrait of him by Wright of Derby (see no. 9). LL.D., 1764; Professor of Arabic, 1768–70; Regius Professor of Civil Law, 1770–82. Ordained in 1757, he became Chaplain to the King in 1774, Bishop of Gloucester, 1781–9, and Bishop of St Asaph, 1789–90.

A stipple engraving by Godby after the miniature is lettered 'Edridge pinx. 1788'. The miniature was given to the Museum by Arthur Jaffé in 1952.

EXHIBITED: London, R.A., 1788, no. 317, as *'Portrait of a bishop'; idem*, 1952, no. 617; London, Goldsmiths' Hall, 'Treasures of Cambridge', 1959, no. 351.

Fitzwilliam Museum (PD. 15-1952)

John Smart (1741?–1811)

47 *Charles, 1st Marquess Cornwallis, P.C.* 1793

Watercolour on ivory
Oval, 6.0 × 4.6 cm ($2\frac{3}{8} \times 1\frac{13}{16}$ in)
Signed and dated 1793

Charles Cornwallis, Viscount Brome (1738–1805) was admitted to Clare as a nobleman in 1755. Professional soldier, and M.P. for Eye, 1760–2. Succeeded his father as 2nd Earl Cornwallis, 1762. Served in America, 1776–81. Lord of the Bedchamber and A.D.C. to the King, 1765. Vice-Treasurer of Ireland, 1769–70. P.C., 1770. Envoy Extraordinary to Frederick the Great, 1785. He is noted for his reforms of the administration as Governor General of Bengal and Commander-in-Chief in the East Indies, 1786–93. Created Marquess, 1792. Lord Lieut. of Ireland, 1798–1801, in which capacity he assisted in carrying the Act of Union. Master-General of Ordnance, 1795–1801, and Plenipotentiary at Amiens and a signatory of the Treaty there, 1801–2.

Presumably painted in India, where Smart worked, 1785–95. This miniature was given to the Museum by Mrs W. D. Dickson in 1945. Daphne Foskett, *John Smart*, London, 1964, p. 19, erroneously describes it as being signed and dated 1787. She mentions three other portraits of Cornwallis by Smart (*op. cit.*, Appendix A, p. 65); one dated 1792, a sketch $7\frac{1}{2} \times 7$ in, dated 1792 repr. fig. 71, formerly in the collection of Sir Bruce Ingram, and another dated 1793, exhibited at 158b New Bond Street, London, in 1911, together with a companion miniature of Lady Cornwallis, also drawn in 1793. A further miniature not mentioned by Foskett, identical with the Fitzwilliam miniature but signed and dated 1794, was sold by E. B. H. Travers at Sotheby's, 27 November 1972, lot 169, repr., bt. Meredith.

Fitzwilliam Museum (no. 3922)

Andrew Plimer (1763–1837)

48 *Sir Brooke Boothby, Bart.*

Watercolour on ivory
Oval, 5.6 × 6.5 cm (2⅛ × 2½ in)

Brooke Boothby (1744–1824), author, was admitted to St John's as a pensioner in 1761. He succeeded his father as 6th Baronet in 1789. His literary acquaintances included Erasmus Darwin, the Edgworths and J-J. Rousseau.

This miniature was bought from Thomas Agnew & Sons by F. Leverton Harris, and bequeathed by him to the Museum in 1926.

Fitzwilliam Museum (no. 3767)

Jean Auguste Dominique Ingres (1780–1867)

49 *Henry George Wandesforde Comber with Mr and Mrs Joseph Woodhead* 1816

Pencil on paper
30.4 × 22.4 cm (12 × 8⅞ in)
Signed in pencil, lower right, 'Ingres a rome 1816'

Henry George Wandesforde Comber (1798–1883) matriculated at Jesus in 1821, and eventually took holy orders to become Rector of Oswaldkirk, Yorkshire, and Vicar of Creech St Michael, Somerset. In 1815–16, he travelled abroad with his sister Harriet (1793–1872) and her husband Joseph Woodhead (1774–1866), then on their honeymoon. The three were in Rome in 1816, where they sat to Ingres. The artist received the equivalent of about thirty shillings for the drawing.

This is one, very fine, example of the many portraits drawn by Ingres in Rome between 1806 and 1820, in his phrase: 'une quantité immésurable de portraits dessinés d'Anglais, de Français et de toutes les nations'. (H. Lapauze, *Les Dessins de J. A. D. Ingres au Musée de Montauban*, Paris, 1901, p. 248.)

The drawing passed by descent from the Woodheads to Brigadier-General Henry Alexander Walker. He sold it in 1947 to the National Art-Collections Fund, which presented it to the Museum.

EXHIBITED: London, Goldsmiths' Hall, 'Treasures of Cambridge', 1959, no. 74; Arts Council of Great Britain, 'Sixty Years of Patronage', 1965, no. 37, repr; Liverpool, Walker Art Gallery, 'Gifts to Galleries' (N.A.-C.F.),

29

1968, no. 46, repr.; Paris, Galerie Heim; Lille, Palais des Beaux-Arts; Strasbourg, Musée des Beaux-Arts, 'Cent Dessins Français du Fitzwilliam Museum', 1976, no. 50, repr.; New York, Pierpont Morgan Library; Fort Worth, Kimbell Art Museum; Baltimore Museum of Art; Minneapolis Institute of Arts; Philadelphia Museum of Art, 'European Drawings from the Fitzwilliam', organised and circulated by the International Exhibitions Foundation, 1976–7, no. 108, repr.

LITERATURE: Brinsley Ford, 'Ingres Portrait Drawings of English People at Rome, 1806–20', *Burlington Magazine*, LXXV, 1939, pp. 7–8, plate 1; National Art-Collections Fund, *Annual Report*, 1947, p. 20, no. 1459, repr.; J. Alazard, *Ingres et l'Ingrisme*, Paris, 1950, pp. 63, 147, no. 14, repr. plate xxxvi; Winter, p. 392, no. 99, plate 99.

Fitzwilliam Museum (PD. 52-1947)

J. Pelham (active *c.* 1820)

50 *The Rev. Joseph Turner, D.D., F.S.A.*

Silhouette in black pigment on glass, coated inside with white wax (treated and backed with white card, 1967)
Oval, 8.6 × 7.0 cm ($3\frac{3}{8} \times 2\frac{3}{4}$ in)
Inscribed on a label stuck to the back of the frame, in the handwriting of G. Ainslie;
'G Ainslie's/the Revd. Dr Joseph Turner/Dean of Norwich and/Master of Pembroke College/Cambridge. Aet: 76/Obiit Aug. 1828, aetatis/Ann. 84'
Below this, in another hand, 'J. Pelham. 13 Surry Street. Norwich./A.D. 1821'

Dr A. V. Grimstone has suggested that the artist may be James Pelham, the younger (1800–1874), who 'in early life travelled about the kingdom, painting portraits of notable persons, especially in the eastern counties and in Bath and Cheltenham'. (Bryan's *Dictionary of Painters and Engravers*, 3rd edition, reprinted 1904, IV, p. 87.)

Joseph Turner was admitted to Pembroke as a sizar in 1763. B.A. (Senior Wrangler) 1769. A fellow of Pembroke, he was one of the tutors of Pitt the Younger. Master, 1784–1828. He served as Vice-Chancellor, 1785–6 and 1805–6.

Pembroke College

George Richmond, R.A. (1809–1896)

51 *Henry Venn*

Watercolours on paper
30.5 × 22.5 cm (12 × 9 in)
Signed lower left, 'Geo. Richmond delt̪ 18?' (ascribed by J. Venn, *Annals*,
to 1831)

Henry Venn (1796–1873) was the seventh of nine generations of the Venn
family to graduate at Oxford or Cambridge. His son John became President
of Gonville and Caius; while his grandson John Archibald, President of
Queens' from 1932 to 1958, is remembered as the compiler of *Alumni Canta-brigienses*. He himself was admitted to Queens' as a pensioner in 1814, and
was a fellow from 1819 to 1829. He was Secretary from 1841 to 1873 of the
Church Missionary Society, of which his father had been one of the founders;
and a later portrait (1862) was painted by Richmond for the Society (Knight,
op. cit., frontispiece, in the engraving by Samuel Cousins).

This is a characteristic sketch by the immensely prolific George Richmond.
'While other artists, painting laboriously in oils have, in comparison,
achieved numerically a few portraits, he has preserved for us all the promi-
nent men of an entire generation, who thus live for us with their individu-
ality intact beneath the magic spell of his tireless pencil; he was, in fact,
the great pictorial historian of his time.' (A. M. W. Stirling, *The Richmond
Papers*, London, 1926, p. 52.) The date of acquistion by the College is not
known.

LITERATURE: William Knight, *Memoir of the Rev. H. Venn*, London, 1880;
J. Venn, *Annals of a Clerical Family*, London, 1904, p. 288, repr. plate opp.
p. 148.

Queens' College

Unknown artist

52 *George Archdall-Gratwicke*

Watercolour on ivory
7.6 × 6.3 cm (3 × 2½ in)

George Archdall, B.D. (1787–1871) was admitted to Emmanuel as a
pensioner in 1811. He became a fellow, 1817, and Master, 1836–71. He served
as Vice-Chancellor in 1835 and 1841. He assumed the additional name of
Gratwicke in 1863.

The miniature was presented to the College by the Rev. R. V. C. Kinleside, M.A.

Emmanuel College

William Strang, R.A. (1859–1921)

53 *Montague Rhodes James, Litt.D.* 1909

Red, black and white chalks on paper
45.8 × 29.2 cm (18 × 11½ in)
Signed and dated, in black chalk, 'W. STRANG 1909'; and inscribed in pencil with the name of the sitter

M. R. James (1862–1936), antiquary and author, was admitted to King's, a scholar from Eton, in 1882. He took the Carus Prize that year. He became a Bell Scholar in 1883, and a Craven Scholar in 1884, when he was also awarded the Jeremie Septuagint prize. M.A., 1889, Litt.D., 1895. Fellow of King's, 1887–1905, Dean and Tutor; Provost, 1905–18. He served as Vice-Chancellor, 1913–14. Director of the Fitzwilliam Museum, 1893–1908. Provost of Eton, 1918–36.

Strang's portrait drawings are well represented in Cambridge collections. Among others, there is one of *C. R. Ashbee* in King's and portraits of the poets *Robert Bridges* and *W. B. Yeats* in the Fitzwilliam. This drawing, of which a coloured reproduction, slightly reduced in size, was made by Emery Walker, was given to the Museum by the artist in 1909.

EXHIBITED: London, Goldsmiths' Hall, 'Treasures of Cambridge', 1959, no. 95; Cambridge, Fitzwilliam Museum, 'Modern Literary Manuscripts from King's College, Cambridge. An Exhibition in memory of A. N. L. Munby', June–July 1976, no. 22.

Fitzwilliam Museum (no. 691)

Augustus Edwin John, O.M., R.A. (1878–1961)

54 *Louis Colville Gray Clarke* 1915

Pencil
45.8 × 31.9 cm (18 × 12\frac{9}{16} in)
Signed and dated, right, 'John./1915'
Inscribed in pencil, below, probably by the mounter: 'Mr Louis Clarke/Berkeley House/Hay Hill/W', over a preliminary sketch of the same sitter

(For details and other portraits of the sitter, see nos. 36, 71.)

32

The sitter became friendly with John soon after 1910, and amassed a considerable collection of his works, this drawing among them, which he bequeathed to the Museum with his other treasures in 1960. He sat to John on a number of occasions; two other drawings of him were given to the Museum by the artist's son, Admiral Sir Caspar John, in 1969 (PD. 28 and 29-1969). They relate in turn to the portrait in oils painted *c.* 1920, which Dr Clarke gave to Trinity Hall, in 1960.

LITERATURE: Lord David Cecil, *Augustus John. Fifty-two Drawings*, London, 1957, repr. plate 29.

Fitzwilliam Museum (PD. 168-1961)

William Rothenstein (1872–1945)

55 *Henry Montagu Butler, D.D.* 1916

Crayon
35.5 × 25 cm (14 × 8⅞ in)

(For details and other portraits of the sitter, see no. 26.)

According to the College records, drawn in 1916.

Trinity College

56 *John McTaggart Ellis McTaggart, Litt.D.* 1916

Pencil
35.5 × 25 cm (14 × 9⅞ in)

J. McT. E. McTaggart (1866–1925) was admitted to Trinity as a pensioner in 1885. He became a scholar and took Members' and Marshall prizes in 1888, M.A., 1892, Litt.D., 1902. President of the Cambridge Union Society, 1890. Fellow of Trinity, 1891 and Lecturer in Moral Sciences, 1897–1923.

According to the College records, drawn in 1916. A portrait of McTaggart by his friend Roger Fry also belongs to the College.

Trinity College

Francis Dodd (1874–1949)

57 *James Whitbread Lee Glaisher, P.R.A.S., F.R.S., Sc.D.*

1927

Pencil

38 × 28 cm (15 × 11 in)

Signed in pencil, upper right, 'Francis Dodd/June 1927' and inscribed, upper left, with the name of the sitter

James Whitbread Lee Glaisher (1848–1928) was admitted to Trinity as a pensioner in 1866. He became a scholar in 1868, took his M.A. in 1874; Sc.D. 1887. He was a fellow of Trinity 1871–1928, serving as Tutor, 1883–93. Lecturer in Mathematics, 1871–1901. F.R.S., 1875, De Morgan Medal, 1908. President of the Royal Astronomical Society, 1886–8 and 1901–3. A great authority on faience and pottery, he bequeathed his splendid collections to the Fitzwilliam.

According to the College records, drawn in 1927.

Trinity College

Henry Lamb (1885–1960)

58 *Sir Horace Lamb, Sc.D., F.R.S.*

1927

Pencil

35.5 × 25.5 cm (14 × 10 in)

Signed and dated in pencil, lower right, 'Henry Lamb/27'

Horace Lamb (1849–1934), the artist's father, was admitted to Trinity as a sizar in 1867. He became a scholar in 1870 and a fellow in 1872. M.A., 1875, Hon. Sc.D., 1908. Held Chairs of Mathematics in Adelaide, and in Manchester. Honorary fellow of Trinity, 1920. President of the British Association, 1925. Knighted, 1931.

LITERATURE: *Artwork*, 1929, repr. p. 261; Sir J. Duveen, *Thirty Years of British Art*, London, 1930, p. 136.

Trinity College

Eric Gill (1882–1940)

59 *Francis Macdonald Cornford, Litt.D., F.B.A.* 1929

Pencil
37.5 × 25.7 cm (14¾ × 10⅛ in)
Signed in pencil, lower right, 'Eric G', and inscribed in pencil twice, lower left, once crossed out, 'after F. M. Cornford'

Francis Cornford (1874–1943) was admitted to Trinity as a pensioner in 1893. He became a scholar in the following year, took the Chancellor's Medal (Classics) and his B.A. in 1897, and was elected to a fellowship in 1899. Lecturer in Classics, 1904, and Laurence Professor of Ancient Philosophy, 1931–9.

According to the College records, drawn in 1929.

Trinity College

William Roberts (b. 1895)

60 *Professor Frederick James Dykes* 1932

Pencil
45.9 × 31.8 cm (18 × 12½ in)
Signed in pencil, lower right, 'William Roberts'

Frederick James Dykes (1880–1957) was admitted to Trinity as a sizar in 1899. He became scholar in 1901 and a fellow in 1906, the year in which he took his M.A. Tutor, 1919–33. College and University Lecturer in Mechanical Sciences, 1906–37, and technical adviser to industry.

According to the College records, drawn in 1932.

Trinity College

Michael Ayrton (1921–1975)

61 *Arthur David Waley, C.H., F.B.A.* 1957

Pencil
31.8 × 49.5 cm (12½ × 19½ in)
Signed and dated in pencil, lower right, 'Michael Ayrton/2-6-12-1957'

Arthur Waley (1889–1966), translator of Chinese literature and late Assistant Keeper in the Department of Prints and Drawings, British Museum. He was admitted to King's; B.A., 1910; Honorary fellow, 1946.

The drawing was commissioned by the College.

King's College

Renato Guttuso (b. 1912)

62 *Piero Sraffa, F.B.A.* 1961

Pencil
56.8 × 36.2 cm (20 × 14¼ in)
Signed, lower right, 'Guttuso'

Piero Sraffa (b. 1898), a fellow of Trinity since 1939, and Emeritus Reader in Economics.

Drawn in April, 1961. Guttuso also painted at about this time a portrait of Lord Annan as Provost of King's.

Trinity College

David Hockney (b. 1937)

63 *Professor Sir Edmund Ronald Leach, F.B.A.* 1971

Black ink on paper
42.5 × 3.5 cm (16¾ × 13¾ in)
Inscribed, 'Edmund Leach/King's College Cambridge/Nov 6th 1971/DH'

Sir Edmund Leach (b. 1910), Professor of Social Anthropology, and Provost of King's since 1966, began his Cambridge career as an undergraduate at Clare; B.A., 1932. He was lecturer, and later Reader in Social Anthropology at the London School of Economics, 1947–53. He was a University lecturer at Cambridge 1953–7, and a fellow of King's, 1960–6.

This drawing was given to the College by the sitter in 1976.

King's College

III SCULPTURE

Joseph Nollekens, R.A. (1737–1823)

64 *The Hon. William Pitt, P.C., F.S.A.* *c.* 1807

Whole length, plaster
H: 41 cm (18½ in)

William Pitt (1759–1806) was admitted a fellow-commoner at Pembroke Hall in 1773. He became M.A. in 1776. He first entered Parliament in 1781, becoming Chancellor of the Exchequer in the following year. He was M.P. for the University of Cambridge, 1784–1806, and High Steward of the University, 1790–1806. He was Prime Minister 1783–1801, and 1804–6. The Pitt Scholarship was founded in 1806 from the surplus of the subscription fund formed for the statue of him by Nollekens. In 1824 the surplus from another fund, subscribed for a statue of him in Hanover Square, was assigned to the erection of the Pitt Press.

This presumed cast from the winning model in the competition for a life-sized statue of Pitt to be placed in the Senate House, was bequeathed to the Fitzwilliam by Mrs J. Hayles, 1854. The finished marble was erected in 1812.

LITERATURE: Goodison, 1955, p. 33, no. 38 repr. plate XVII for the marble, and p. 101, no. 159 for the model. The competition is discussed by N. B. Penny, 'To Honour Pitt the Younger', *Country Life*, 19 May 1977 and by R. W. Liscombe, 'Canova, Aberdeen and the Pitt Monument', *Burlington Magazine*, October 1977, pp. 700–5.

Fitzwilliam Museum

Sir Francis Chantrey, R.A. (1781–1841)

65 *John Horne Tooke* *c.* 1811

Bust, marble
H: 62.2 cm (24½ in)
Signed, 'F. CHANTREY. SC'

John Horne Tooke (1736–1812) was admitted to St John's in 1754. He took his B.A. in 1758, and became M.A. in 1771. Philologist and radical pamphleteer, he was tried for high treason in 1794, and acquitted. This bust was the making of Chantrey's reputation, although it had to be exhibited

in 1811 as a plaster because neither sitter nor sculptor could afford marble. The model, or a cast thereof, is in the Ashmolean Museum, Oxford. The date of this marble (which was given to the Fitzwilliam by Lady Chantrey in 1861), is uncertain; although it was certainly carved before the artist's death.

EXHIBITED: London, R.A., 'The First Hundred Years of the Royal Academy', 1951–2, no. 183; London, Goldsmiths' Hall, 'Treasures of Cambridge', 1959, no. 13.

LITERATURE: Goodison, 1955, p. 87, no. 123, repr. plate xx.

Fitzwilliam Museum

Edward Hodges Baily, R.A. (1788–1867)

66 *Sir John Herschel, F.R.S.* 1850

Bust, marble
H: 66 cm (26½ in)
Signed, 'E. H. Baily R A Sculp 1850'

John Frederick William Herschel (1792–1871), astronomer, was a B.A. of Trinity, 1813 (Senior Wrangler), and fellow 1813–29. He was co-founder of the Analytical Society at Cambridge, 1813, Fellow of the Royal Society, 1813, and Secretary of the Royal Society 1824–7. He was created a baronet in 1838. He was the son of an equally famous father, the self-taught astronomer Sir William Herschel. The bust was bought by St John's in 1867.

EXHIBITED: London, R.A. 1850, no. 1435.

St John's College

Thomas Woolner, R.A. (1825–1892)

67 *The Rev. Adam Sedgwick, LL.D., F.R.S.* 1860

Bust, marble
H: 68 cm (26¾ in)
Signed, 'T. WOOLNER Sc/LONDON'

Adam Sedgwick (1785–1873) was admitted to Trinity in 1804, awarded a scholarship, 1807, took his B.A., 1808, and became M.A. in 1811. He had become a fellow in 1810. He was appointed Woodwardian Professor of Geology, 1818. He became an F.R.S. in 1830 and a canon of Norwich in 1834. He received an Hon. LL.D. at Cambridge in 1866. The Sedgwick Museum of Geology, opened in 1904, was built as a memorial to him.

A plaster variant, presumably after the model for this marble, was given to the Department of Geology in 1920 by W. W. Powell.

LITERATURE: Goodison, 1955, p. 145, no. 263 (the variant).

Trinity College

68 *William Whewell, D.D., F.R.S.* 1870–2

Whole length, seated, plaster
H: 59 cm (23¼ in)

William Whewell (1794–1866) was admitted to Trinity in 1811 and became a scholar in 1815; a B.A. in 1816; a fellow in 1817; M.A. in 1819; B.D. in 1838; D.D. in 1844, and F.R.S. 1820. He was Professor of Mineralogy, 1828–32, and Knightbridge Professor of Moral Philosophy 1838–55. He was Master of Trinity, 1841–66.

Cast from the model for the memorial in Trinity College Chapel, dated 1872. Another version, traceable to Woolner's studio, is in an English private collection. The statue was given to Newnham by Miss Bear in 1915.

Newnham College

Sir William Goscombe John, R.A. (1860–1952)

69 *William Cavendish, 7th Duke of Devonshire, K.G., LL.D., F.R.S.* c. 1901

Full-length, seated, bronze
H: 69.8 cm (27½ in)
Signed, 'W. Goscombe John, A.R.A.'

Lord Hartington (1808–1891) was admitted to Trinity in 1825. He became B.A., M.A., and F.R.S. 1829; Hon. LL.D., Cambridge, 1835; M.P., 1829–34. He succeeded to the dukedom, and became K.G. in 1851. Elected Chancellor of the University in 1861, he gave and equipped the Cavendish Laboratory of Experimental Physics in 1870. He is commemorated among the benefactors of the University.

This is a cast from the model for the colossal bronze at Eastbourne, which was erected by public subscription in 1901. It was given to the University by the Committee and subscribers in 1908. A portrait of the Duke by G. F. Watts, painted in 1883, was given to the University by subscribers in that year (Fitzwilliam Museum, no. 503).

EXHIBITED: (the model) Paris, 'Salon 1901', no. 3226.

LITERATURE: Goodison, 1955, p. 115, no. 191.

The University (Old Schools)

Emile-Antoine Bourdelle (1861–1929)

70 *Sir James George Frazer, O.M., F.R.S., F.B.A.* 1922

Bust, bronze
H: 67 cm (26⅜ in)
Signed, 'Sculpteur Antoine Bourdelle', with founder's marks

Sir James George Frazer (1854–1941) was admitted to Trinity in 1874, awarded a scholarship in 1875, took his B.A. in 1878 and became M.A. in 1881. He was a fellow of the College from 1879–1941. His most famous work, *The Golden Bough*, was first published in 1890. He was knighted in 1914. He became an F.R.S. in 1920. In 1925 he became an F.B.A. and was awarded the O.M.

Trinity College

Sir Jacob Epstein, K.B.E. (1880–1959)

71 *Louis Colville Gray Clarke* 1951

Bust, bronze
H: 53.3 cm (21 in)
Signed and dated at back, 'Epstein 1951'

(For details of the sitter, see no. 36.)

The bust was commissioned for the purpose of presentation to the Museum, and given by the Friends of the Fitzwilliam in 1951.

LITERATURE: Friends of the Fitzwilliam Museum, *Annual Report*, 1951, repr. front cover and p. 3; Goodison, 1955, p. 140, no. 251.

Fitzwilliam Museum

72 *Sir James Gray, C.B.E.* 1956

Bust, bronze
H: 62.2 cm (24½ in)
Signed, 'Epstein'

Sir James Gray (1891–1975) was a scholar at King's, where he became a fellow in 1914. He was Professor of Zoology, 1937–59, thereafter Emeritus. He was a Trustee of the British Museum 1948–60. The bust was given to the Department of Zoology by subscription in 1956.

EXHIBITED: London, Goldsmiths' Hall, 'Treasures of Cambridge', 1959, no. 19.

University of Cambridge (Department of Zoology)

IV MEDALS AND PLAQUES

These are part of the Museum's extensive holding of English portrait medals, which contains the superb gift of A. W. Young, 1936, and loans made by several Colleges.

Thomas Simon (1618–1665)

73 *General George Monk, later Duke of Albemarle, K.G., F.R.S.* 1660

Cast lead medal, dated 1660
Diam. 38 mm
Obverse. Bust right, no inscription
Reverse. GEORGIVS MONKE. OMNIVM. COPIARVM. IN. ANGLIA SCOTIAE ET.HIBERNIA EDVX.SVPREMVS.ET THALASSIARCHA AETA:52.1660

George Monk (1608–70) was admitted to King's as a fellow-commoner in 1627. The medal was struck when he was effectively Head of State, as Commander of both military and naval forces. A new Parliament met in April 1660 and voted in May to restore the monarchy. Monk met Charles II at Dover on 25 May. Created Duke of Albemarle, 1660.

The medal reproduces the unique gold specimen in the British Museum which has grammatical errors in the inscription, and was consequently left unfinished by the artist. This example was given to the Museum by B. E. Bonnett in 1975.

LITERATURE: *Medallic Illustrations*, I, p. 465, no. 63.

74 *King Charles II* 1661

Struck silver coronation medal, April 1661
Diam. 30 mm
Obverse. Bust right, CAROLVS .II.D.G.ANG.SCO.FR.ET HI.REX
Reverse. The king enthroned, and being crowned by a flying figure of Peace EVERSO. MISSVS. SVCCVRRERE. SECLO. XXIII APR. 1661 (Sent to support a fallen age, 23 April 1661)

Charles, as Prince of Wales, was admitted M.A. in March 1641–2, during a visit to the University.

The reverse legend is adapted from Vergil, *Georgics* i. 500. The artist charged £110 for the preparation of the medal, which was distributed at the ceremony.

LITERATURE: *Medallic Illustrations*, I, p. 472, no. 76.

Trinity College

Thomas Rawlins (1620–1670)

75 *King Charles II* 1661

Struck silver coronation medal, April 1661
Diam. 33 mm
Obverse. Bust left, CAROLVS.II D:G:MAG:BRI:FRA:ET.HI:REX. CORONATVS
Reverse. Standing figure of the King as a shepherd, holding a crook and surrounded by flocks of sheep. DIXI.CVSTODIAM.XXIII.APRIL.1661 (I have said I will keep them. 23 April 1661)
Around the edge: CORONATO.PASTORE.OVAT.OVILE. (The fold rejoices when the Shepherd is crowned)

(For details of sitter, see no. 74.)

The reverse type and inscriptions allude to the image of the King as Shepherd, also recorded by Edmund Waller in his poems on the Restoration – 'Here, like the people's pastor'.

The medal was given to the Museum by A. W. Young in 1936.

LITERATURE: *Medallic Illustrations*, I, p. 473, no. 78.

Thomas Simon (1618–1665)

76 *Thomas Wriothesley, 5th Earl of Southampton* 1664

Cast silver medal, dated 1664
Diam. 42 mm
Obverse. Bust left, no inscription
Reverse. THOMAS.COMES SOVTHAMPTONIAE SVMMVS.ANGLIAE THESAVRARIVS &c. MDCLXIIII

Thomas Wriothesley (1607–67) at one time at St John's. High Steward of the University, 1642–61. The reverse inscription records that Wriothesley was Lord High Treasurer of England, an office which he held from 1660 to 1667. The specimens of the medal in gold in the British Museum are the

artist's masterpieces. This one was given to the Museum by A. W. Young in 1936.

LITERATURE: *Medallic Illustrations*, I, p. 502, no. 138.

Jean Dassier (1676–1763)

77 *John Milton*

Struck copper memorial medal
Diam. 40 mm
Obverse. Bust of Milton, facing. IOANNES MILTON.
Reverse. A scene representing Paradise Lost, Adam and Eve seated by a tree with the serpent, demons entering and wolves devouring flocks DIRA DVLCE CANIT ALTER HOMERUS. (A second Homer sweetly sings direful events.) In exergue I.D.

John Milton (1608–74) was admitted to Christ's, 1624–25. He took his M.A. in 1632. At Cambridge he wrote Latin poems on University events and, among his poems in English, an *Ode on the Nativity*, 1629, and the *Sonnet to Shakespeare*, 1630.

The reverse refers to the opening passage of *Paradise Lost*, published in 1667. The medal is one of a series by Dassier of famous Europeans. The medal was given to the Museum by A. W. Young in 1936.

LITERATURE: *Medallic Illustrations*, I, p. 564, no. 229.

George Bower (d. 1690)

78 *William Sancroft, D.D.* 1688

Struck silver medal
Diam. 51 mm
Obverse. Bust right, GVIL.SANCROFT.ARCHIEPISC.CANTVAR. 1688.
Reverse. Medallion portraits and names of the six bishops arranged around that of the Bishop of London. Below, GB.F
Edge. SI FRACTVS ILLABATUR ORBIS IMPAVIDOS FERIENT RVINAE (If the shattered universe were to fall, the ruins would strike them undismayed)

William Sancroft (1633–93) was admitted to Emmanuel as a pensioner in 1633. He took his M.A. in 1641. He became a fellow of his College in 1642 and was Master, 1662–5. Archbishop of Canterbury, 1678–91.

The medal was struck on the occasion of the imprisonment of the seven bishops in 1688. The edge inscription alludes to Horace, *Odes*, III, iii, 7–8. The bishops were committed to the Tower for opposing the Declaration of Indulgence issued by James II, and for refusing to allow it to be read in the churches. The bishops were, besides Sancroft, Lloyd of St Asaph, Ken of Bath and Wells, Turner of Ely, Lake of Chichester, White of Peterborough, and Trelawney of Bristol. Compton of London is added because he had been suspended from his office by the King, also for resisting the royal attempts to relieve the Roman Catholics of civil and religious disabilities.

The Medal was given to the Museum by A. W. Young in 1936.

LITERATURE: *Medallic Illustrations*, I, p. 622, no. 37.

Giovanni Battista Pozzo (1670–1752)

79 *Conyers Middleton, D.D.* 1727

Obverse and reverse of cast bronze medals made in Rome in 1727
Diam. 81 mm
Obverse. Bust right, CONYERS.MIDDLETON.S.T.P. Below, GIO.
POZZO.F.ROMA. 1724.
Reverse. View of bookcases, a book-laden table, a bust of Minerva on a pedestal. ACADEMIAE.CANTABRIGIENSIS.PROTO.BIBLIOTHE-CARIVS (The chief librarian of the University of Cambridge)

Conyers Middleton (1683–1750) was admitted to Trinity as a pensioner in 1698–9. He took his M.A. in 1706, the year in which he became a fellow of his College. He was University Librarian, 1721–50.

When the King purchased the library of Bishop Moore and presented it to the University, Middleton was appointed the first Chief Librarian to the University. He visited Rome in 1724 and was widely welcomed as a distinguished visitor.

LITERATURE: *Medallic Illustrations*, II, p. 460, no. 71.

Old University Collection

80 *Daniel Wray, F.R.S., F.S.A.* 1726

Cast bronze medal made in Rome in 1726
Diam. 68 mm
Obverse. Bust right, DANIEL.WRAY.ANGLVS.AET.XXIV. (Daniel Wray, an Englishman, aged 24). On truncation, 1726, below, G.POZZO.
F

Reverse. An inscription in four lines, NIL ACTVM REPUTANS CVM QVID SVPERESSET AGENDVM (Not considering anything done, whilst anything remained to be done)

Daniel Wray (1701–83) was admitted to Queens' as a fellow-commoner in 1718–19. He took his M.A. in 1728; incorporated at Oxford, 1731. Antiquarian and deputy Teller of the Exchequer, 1745–82. The reverse inscription refers to Wray's reputation as an official at the Exchequer. He was a Fellow of the Royal Society, Vice-President of the Society of Antiquaries, and a Trustee of the British Museum. The medal was bought by the Museum (S. G. Perceval Fund), 1967.

LITERATURE: *Medallic Illustrations*, II, p. 465, no. 78.

Jean Dassier (1676–1763)

81 *Sir Isaac Newton, F.R.S.*

Struck copper medal
Diam. 33 mm
Obverse. Bust, three-quarters to left, ISAACVS NEWTONIVS
Reverse. A wreath of flowers, enclosing the inscription EQ.AUR.PHILO-SOPHVS.OBIIT 31.MART.1727.NATUS ANNOS 85.(Knight, philosopher, died 31 March 1727, aged 85)

Isaac Newton (1642–1727) was admitted to Trinity as a sizar in 1661. He became a scholar in 1664 and a fellow of his College in 1667. Lucasian Professor, 1669–72. He served as M.P. for the University 1689–90 and 1701–2. Master of the Mint, 1699, and President of the Royal Society, 1703; an office to which he was re-elected annually for 25 years. The *Allegorical Monument to Sir Isaac Newton*, painted 1727–30 by G. B. Pittoni and D. and G. Valeriani, as one of a series of twenty-four paintings representing imaginary monuments of English worthies was purchased by the Museum in 1973. (PD. 52-1973.)

The medal was issued on the death of Newton as a private speculation by Dassier, in London.

EXHIBITED: Cambridge, Fitzwilliam Museum, 'The European Fame of Isaac Newton', 22 November 1973–6 January 1974, no. 45.

LITERATURE: *Medallic Illustrations*, II, p. 470, no. 84.

Trinity College

John Croker (1670–1741)

82 Sir Isaac Newton, F.R.S. 1727

Struck copper medal
Diam. 52 mm
Obverse. Bust left, ISAACVS.NEWTONVS, below, IC
Reverse. Seated figure of Science, leaning on a table and holding a diagram of the solar system, FELIX.COGNOSCERE.CAVSAS (Happy in the knowledge of causes). In exergue, M.DCC.XXVI

This medal was struck on the death of Newton. The post of Master of the Mint which Newton held from 1699 until his death provided his main source of income. Croker was Chief Engraver at the Mint from 1705. The two medals of Newton, by Jean Dassier and by Croker neatly express two contrasted styles of portraiture, the international style of Dassier, and the blunt realism of Croker.

LITERATURE: *Medallic Illustrations*, II, p. 469, no. 83.

Old University Collection

J. A. Dassier (1715–1759)

83 Philip Dormer Stanhope, 4th Earl of Chesterfield, K.G., P.C., F.R.S. 1743

Struck copper medal, dated 1743
Diam. 55 mm
Obverse. Bust left, PHILIPPVS STANHOPE, below, I.A.DASSIER.F.
Reverse. COMES DE CHESTERFIELD.MDCCXLIII in a rococo frame

Philip Dormer Stanhope (1694–1773), diplomat and writer, was admitted to Trinity as a fellow-commoner in 1712. He succeeded to the title as 4th Earl of Chesterfield in 1726.

This medal and the following one belong to a series of thirteen medals with portraits of celebrated Englishmen, produced by Dassier in London between 1740 and 1744. It was bought by the Museum (Coin Duplicates Fund), 1966.

LITERATURE: *Medallic Illustrations*, II, p. 582, no. 222.

84 Robert Walpole, Earl of Orford, K.B., K.G., P.C. 1744

Struck copper medal, dated 1744
Diam. 54 mm

Obverse. Bust left, ROBERTVS WALPOLE, below bust, A.DASSIER
F.
Reverse. COMES DE ORFORD.M.DCC.XLIV. in a rococo frame

Robert Walpole (1676–1745) was admitted to King's, a scholar from Eton, in 1695. He resigned his scholarship in 1698. LL.D., 1728. Prime Minister and Chancellor of the Exchequer, 1715–17 and 1721–42. Created Baron of Houghton, Norfolk, Viscount Walpole and Earl of Orford, 1742.

Like no. 83, one of a series of thirteen medals with portraits of celebrated Englishmen, produced by Dassier in London between 1740 and 1744. The medal was bought by the Museum (S. G. Perceval Fund), 1963.

LITERATURE: *Medallic Illustrations*, II, p. 585, no. 226.

Anonymous medallist

85 *Martin Folkes, F.R.S., D.C.L.* 1742

Struck copper medal made in Rome in 1742
Diam. 36 mm
Obverse. Bust right, MARTINVS FOLKES
Reverse. A sphinx with crescent moon on its side, behind, the tomb of Caius Sestius, above, the meridian sun. SVA SIDERA NORVNT (His own constellations have acknowledged him. In exergue, ROMAE.A.L S742 (At Rome in the year of light, 5742)

The reverse of the medal is a Masonic type, the date on the reverse being blundered for 5742 (A.D. 1742).

Martin Folkes (1690–1754), author and antiquarian, was admitted to Clare as a fellow-commoner in 1706, M.A., 1717; D.C.L. at Oxford, 1746 (incorporated at Cambridge, 1749). President of the Royal Society, 1741–52, and President of the Society of Antiquaries, 1750–4.

The medal was given to the Museum by the Friends of the Fitzwilliam in 1970.

LITERATURE: *Medallic Illustrations*, II, p. 571, no. 206.

Thomas Webb (active 1804–29)

86 *The Hon. William Pitt, P.C., F.S.A.* 1806

Struck copper medal on the death of Pitt
Diam. 53 mm

48

Obverse. Bust left, GVLIELMO PITT R.P.Q.B. Signed on truncation, WEBB

Reverse. A rock set in a stormy sea, PATRIAE COLUMEN DECVS. (The rock and ornament of the nation.) In exergue, OB.A.MDCCCVI (Died in the year 1806)

(For details of the sitter, see no. 64.)

LITERATURE: Forrer, VI, p. 401 (as one of a group of medals for the Pitt Clubs).

Old University Collection

Thomas Wyon, Junior (1792–1817)

87 *The Hon. William Pitt, P.C., F.S.A.* 1813

A frosted-silver medal for the Manchester Pitt Club, 1813
Diam. 50 mm
Obverse. Bust left, RT.HONBLE.WILLIAM PITT.MANCHESTER PITT CLUB.1813. Signed below bust, WYON.
Reverse. Reclining male figure of the genius of Britain on a rock, being exhorted by a standing figure of Pitt to resist the fiends of Anarchy emerging beneath the rock; three standing figures of Virtues watch the scene. In exergue, HIMSELF AN HOST T.WYON.JUN.S.
The medal is glazed and mounted in silver with a loop for suspension by a ribbon

(For details of the sitter, see no. 64.)

The reverse type is signed as Wyon's own work, he also made a number of Pitt Club Medals to designs by Henry Howard R.A., as recorded in Graves, *Royal Academy Exhibitors*, VIII, p. 395. The Museum has a letter from George Canning (1770–1827) dated 1813, proposing another legend for the obverse of this medal (MS 2-1966, p. 47). The medal was given to the Museum by Sam Sandars in 1891.

LITERATURE: Forrer, VI, pp. 646, 647 (illus.).

Thomas Webb (active 1804–29)

88 *William Wilberforce*

Struck copper medal
Diam. 53 mm
Obverse. Bust right, WILLIAM WILBERFORCE M.P. THE FRIEND OF AFRICA. Signed on truncation WEBB

Reverse. Seated figure of Britannia with Minerva and Justice, giving the new Law to a messenger, on dias, I HAVE HEARD THEIR CRY. In exergue, SLAVE TRADE ABOLISHED MDCCCVII.

William Wilberforce (1759–1833) was admitted to St John's as a fellow-commoner in 1776. M.P. for Hull, 1780–4, for Yorkshire 1784–1812 and for Bramber 1812–25, he was the leader in Parliament of the campaign to abolish slavery, from 1787. The medal celebrates the Bill of Abolition of 1807. It was given to the Museum by L. S. Harrisson in 1960.

LITERATURE: Forrer, VI, p. 401.

Gaspare Galeazzi, of Turin (active *c.* 1825)

89 *George Gordon, 6th Baron Byron* 1824

Struck copper medal
Diam. 54 mm
Obverse. Bust right, GEORGIVS BYRON Below, G.GALEAZZI F.
Reverse. A winged genius playing a lyre, AGITANTE CALESCIMVS ILLO (We are inflamed by his singing)

George Gordon (1788–1824) succeeded his great-uncle as 6th Baron Byron of Rochdale in 1798. He was admitted to Trinity as a nobleman in 1805. M.A., 1808.

The medal was struck on Byron's death at Missolonghi in 1824.

Trinity College

L. C. Wyon (1826–1891)

90 *William Wordsworth, D.C.L.* 1848

Struck copper medal
Diam. 36 mm
Obverse. Bust right, no inscription, signed on truncation L.WYON.
Reverse. WILLIAM WORDSWORTH 1848. FRIEND OF THE WISE AND TEACHER OF THE GOOD.

William Wordsworth (1770–1850) was admitted to St. John's as a sizar in 1787. He became a scholar in the same year and took his B.A. in 1791. Hon. D.C.L., Durham, 1836; Hon. D.C.L., Oxford, 1839. Poet Laureate, 1843–50.

The medal was based on a life drawing by the medallist. An example of the medal was exhibited at the Royal Academy in 1848. The reverse inscription is a quotation from Coleridge's poem of 1807 written after he had heard Wordsworth's recitation of *The Prelude*. The specimen was bought by the Museum (Coin Duplicates Fund) in 1966.

LITERATURE: Forrer, VI, p. 629 (illus.); F. Blanshard, *Portraits of Words-worth*, London 1959, plate 30a, b (drawing is dated 21 April 1847).

Allen Wyon (1843–1907)

91 *Charles Robert Darwin, F.R.S.*

Struck gold medal
Diam. 57 mm
Obverse. Bust left, signed on truncation ALLAN WYON SC.
Reverse. CAROLVS DARWIN MDCCIX MDCCCLXXXII within wreath. Below, ALLAN WYON

(For details of the sitter, see no. 20.)

The medal was struck for the Royal Society to mark the Centenary of Darwin's birth, from dies issued in 1882. It was given to the Museum by the Society, in 1909.

Alphonse Legros (1837–1911)

92 *Alfred, 1st Baron Tennyson* 1881

Cast bronze plaque
Diam. 120 mm
Obverse. Bust three-quarters to left, ALFRED TENNYSON Signed on truncation A LEGROS

(For details of the sitter, see no. 22.)

The effigy may be favourably compared with the painting by G. F. Watts (no. 22) and the photographs by Julia Cameron.

The plaque was given to the Museum by Guy Knowles in 1950.

G. W. de Saulles (1862–1903)

93 *Sir George Gabriel Stokes, Bart, F.R.S., LL.D., D.C.L.*
1899

Struck gold medal
Diam. 63 mm
Obverse. Bust left, GEORGE GABRIEL STOKES b. 1819 Signed below,
G. W. de Saulles
Reverse. Latin inscription in 17 lines within wreath of laurel

George Gabriel Stokes (1819–1903) was admitted to Pembroke as a pensioner in 1837; scholar and B.A. (Senior Wrangler), 1841. He was a fellow of his College, 1841–57 and 1869–1902; Master, 1902–3. A pioneer of spectrum analysis, he was Lucasian Professor, 1849–1903. M.P. for the University of Cambridge, 1887–91. Created Baronet, 1889.

The medal was struck on the Jubilee of Stokes' Professorship, 1899. It was given to the Museum by Lady Stokes in 1919.

Percy Metcalfe (1895–1970)

94 *William Whitehead Watts, F.R.S., F.G.S., LL.D.*
1930

Struck bronze medal
Diam. 54 mm
Obverse. Bust left, in field left, W W W, right, P. METCALFE
Reverse. Inscription on Watts in English
On edge, stamped incuse, 'Artist's Copy'

William Watts (1860–1947) was admitted to Sidney Sussex as a pensioner in 1878. He became a scholar in 1881 and a fellow of his College, 1884–94; honorary fellow, 1910–47. Professor of Geology, Imperial College of Science, London, 1906–30.

The medal was struck to commemorate Watt's retirement from his Chair in 1930. It was bought by the Museum (University Purchase Fund), 1972.

THE PLATES

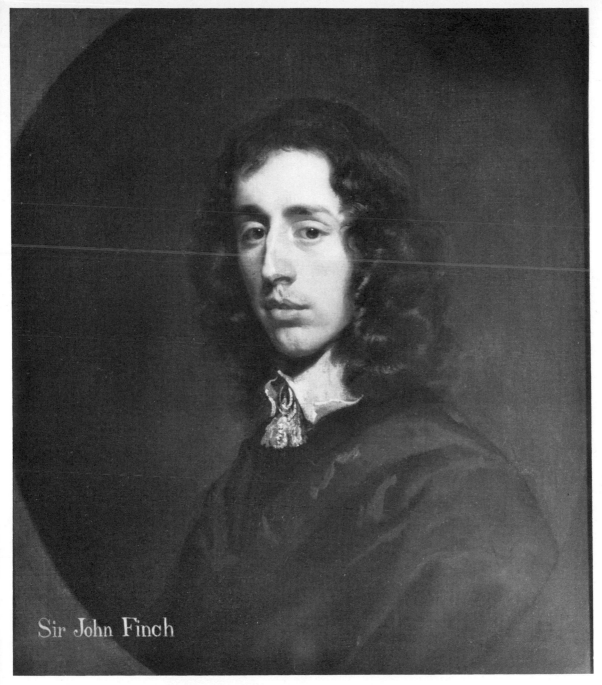

1 Sir Peter Lely, *Sir John Finch*

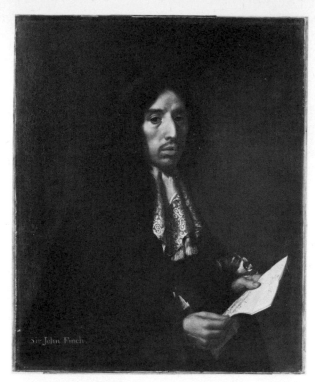

2 Carlo Dolci, *Sir John Finch*

3 Carlo Dolci, *Sir Thomas Baines*

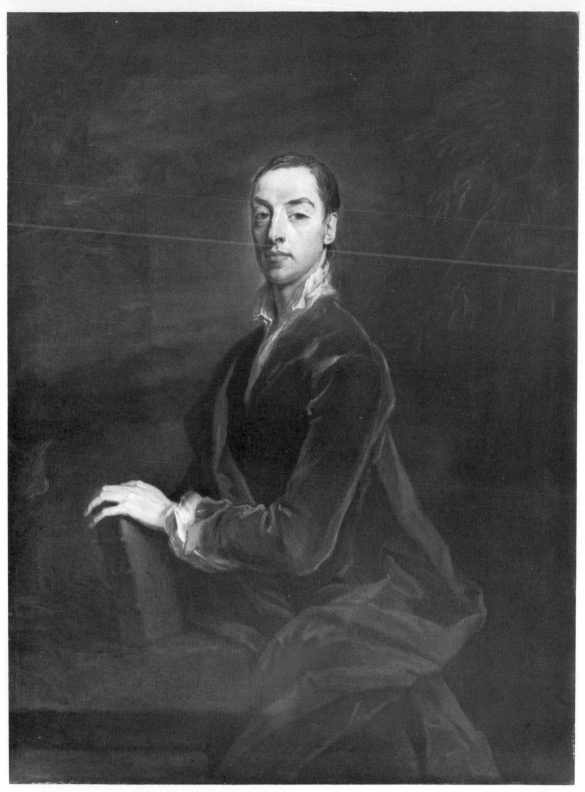

4 Sir Godfrey Kneller, *Matthew Prior*

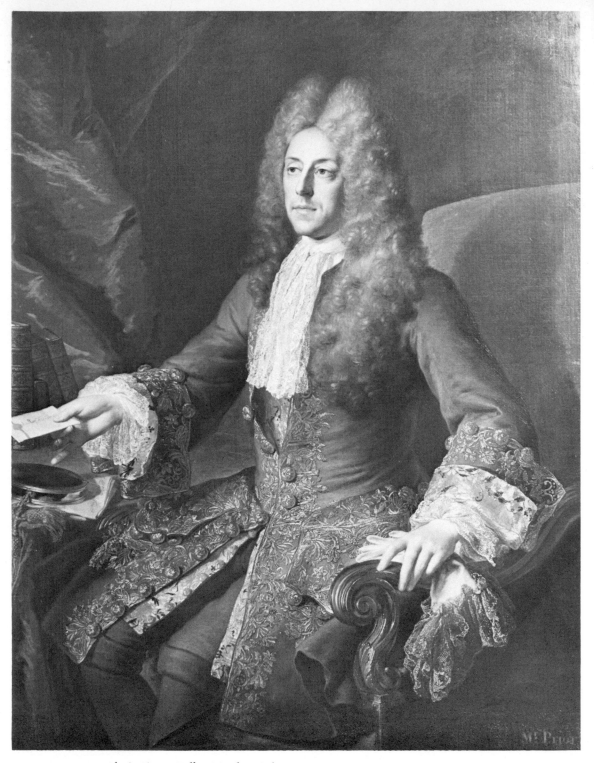

5 Alexis Simon Belle, *Matthew Prior*

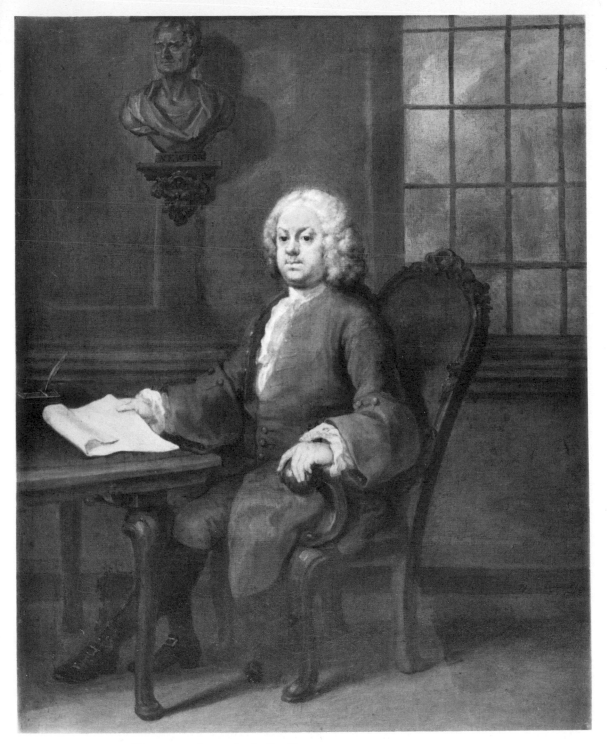

6 William Hogarth, *Benjamin Hoadly*

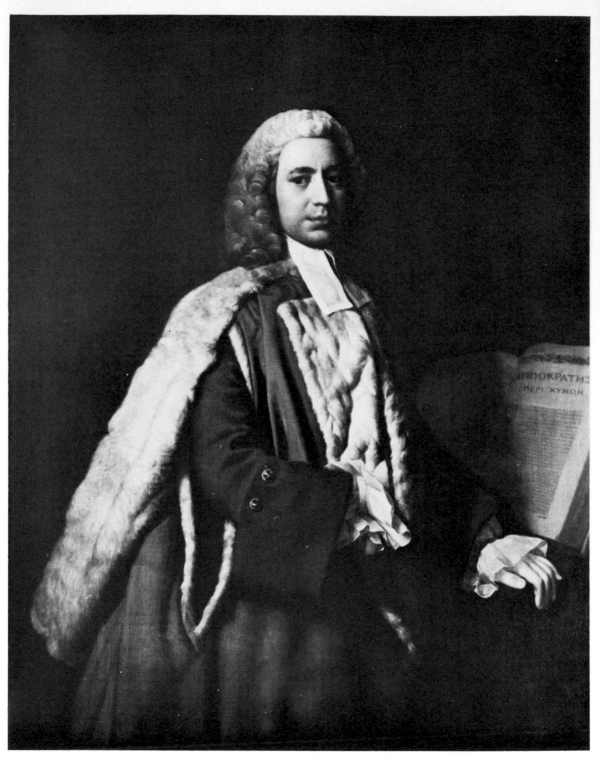

7 Allan Ramsay, *Anthony Askew*

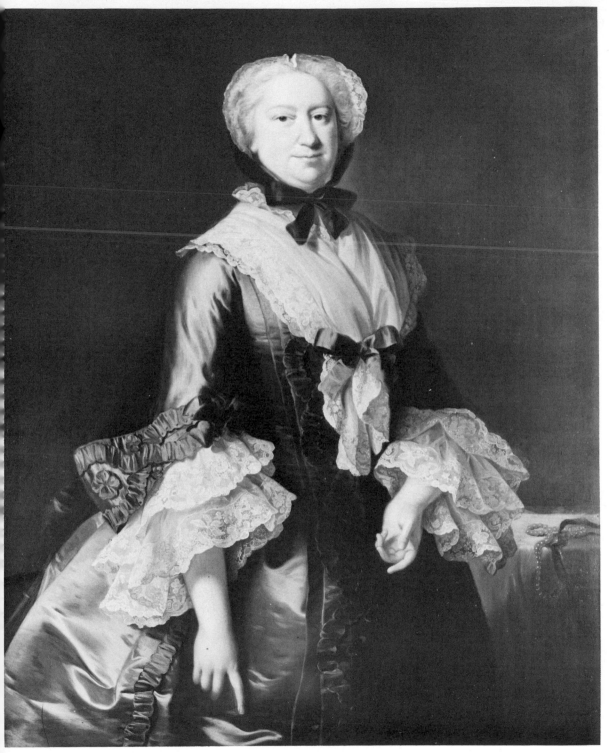

8 Thomas Hudson, *Elizabeth, Countess of Portsmouth*

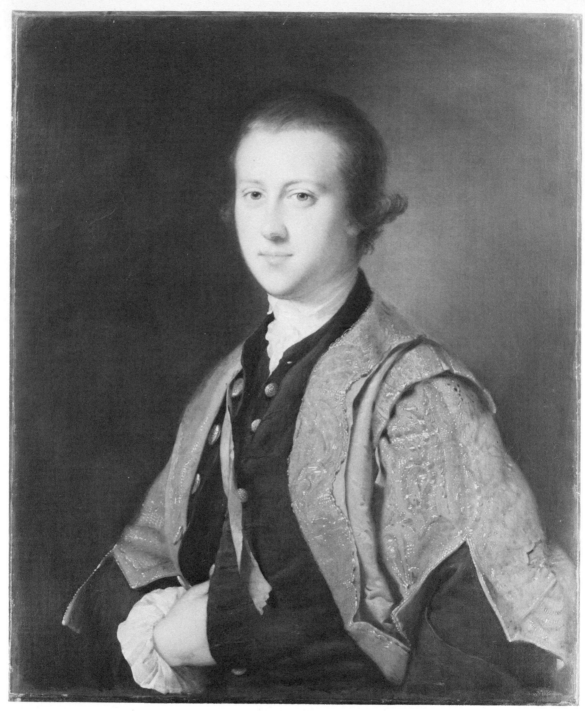

9 Joseph Wright, of Derby, *Richard, 7th Viscount Fitzwilliam*

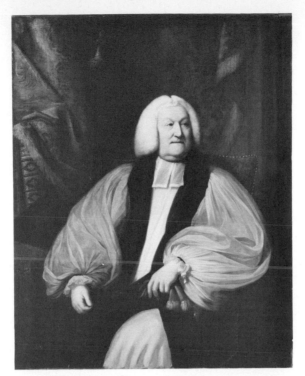

10 Benjamin West, *Richard Newcome, Bishop of St Asaph*

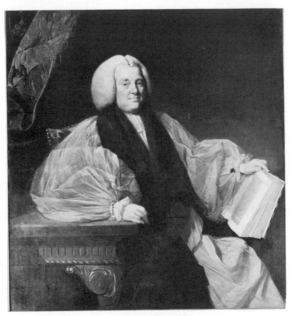

11 Johann Zoffany, *Edmund Keene, Bishop of Chester*

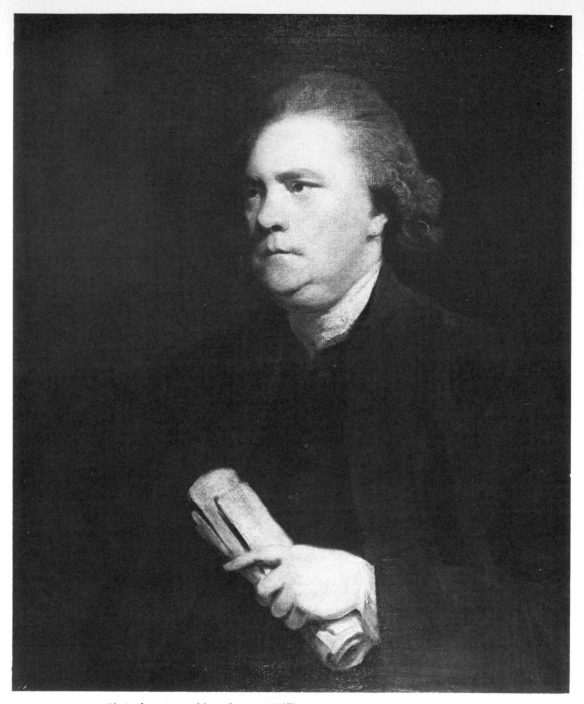

12 Sir Joshua Reynolds, *The Rev. William Mason*

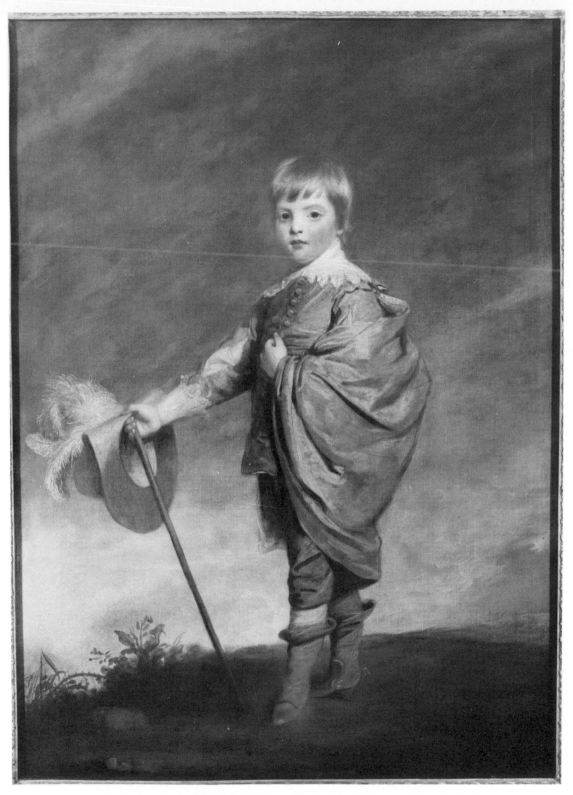

13 Sir Joshua Reynolds, *H.R.H. Prince William Frederick, 2nd Duke of Gloucester*

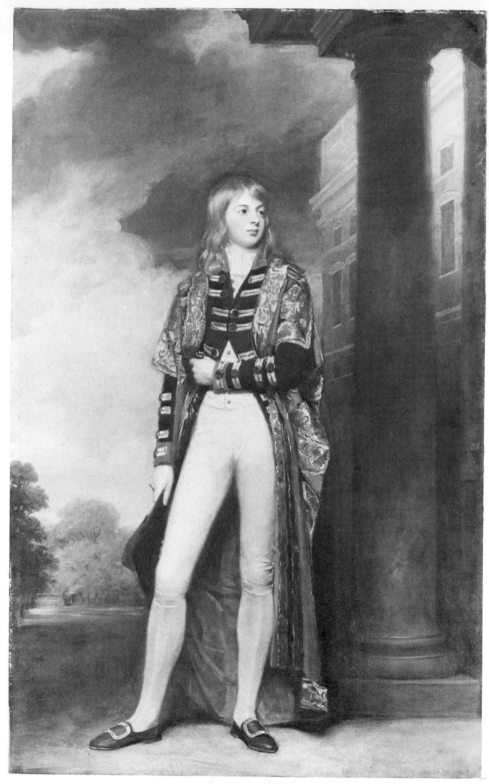

14　George Romney, *H.R.H. Prince William Frederick, 2nd Duke of Gloucester*

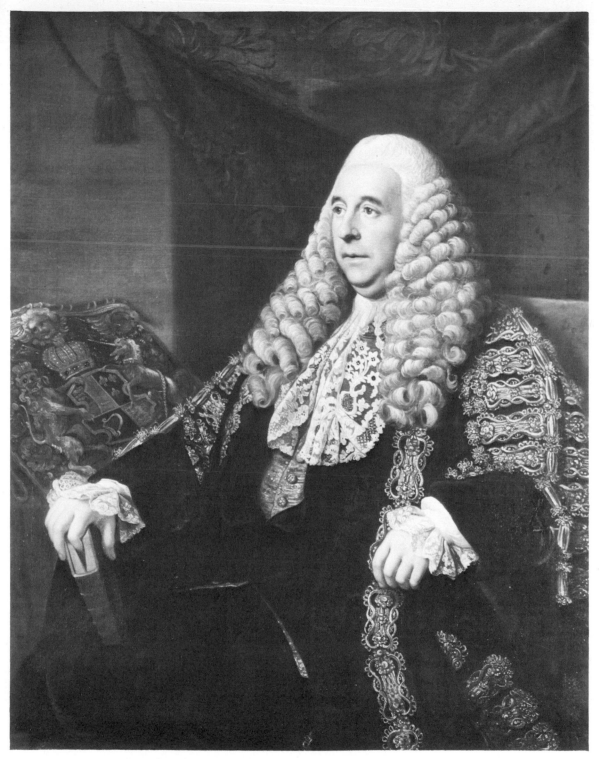

15 Sir Nathaniel Dance-Holland, *Charles Pratt*, *Earl Camden*

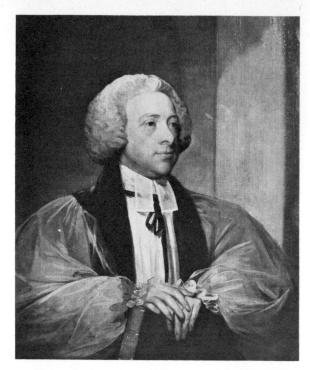

16 Gilbert Charles Stuart, *William Bennet, Bishop of Cloyne*

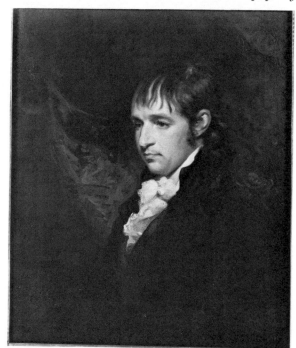

17 John Hoppner, *Richard Porson*

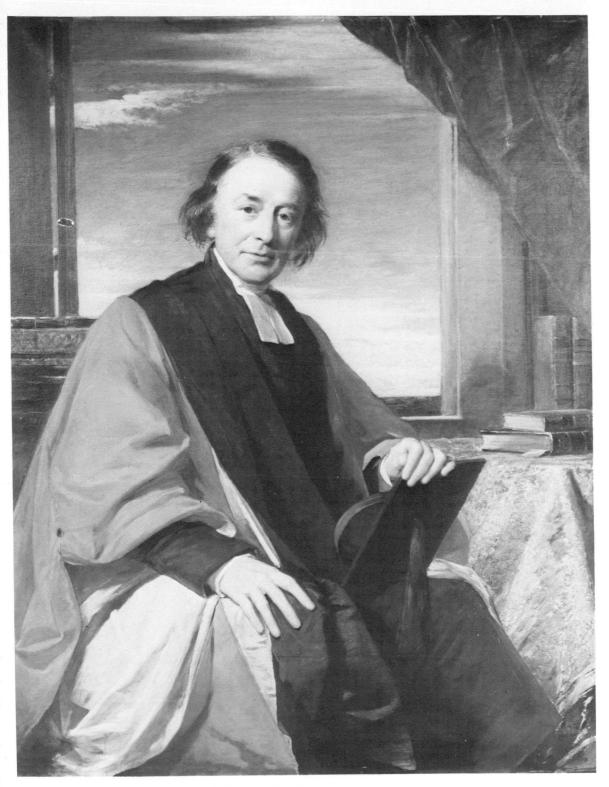

18 George Richmond, *Thomas Worsley*

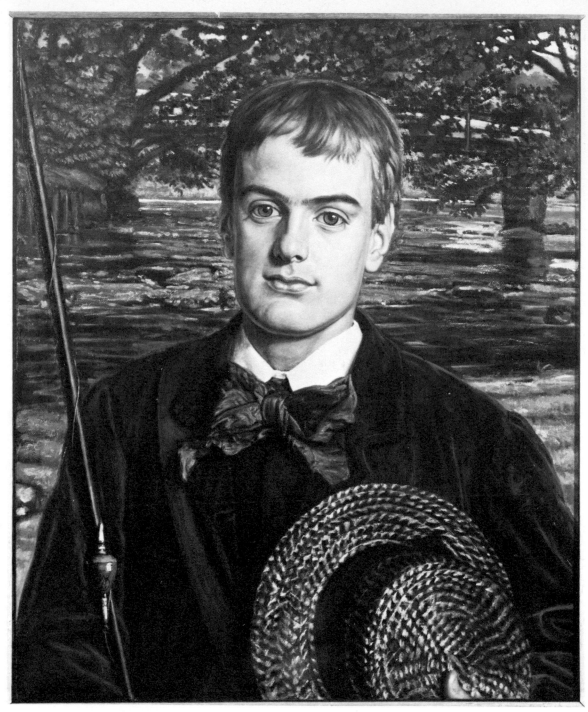

19 William Holman Hunt, *Cyril Benoni Holman Hunt*

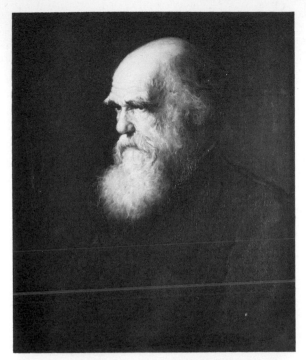

20 Walter William Ouless, *Charles Robert Darwin*

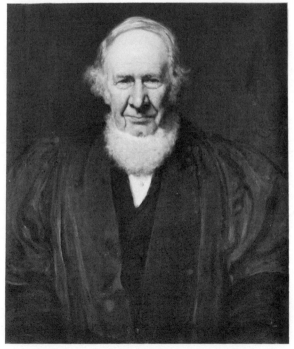

21 Sir Hubert von Herkomer, *George Phillips*

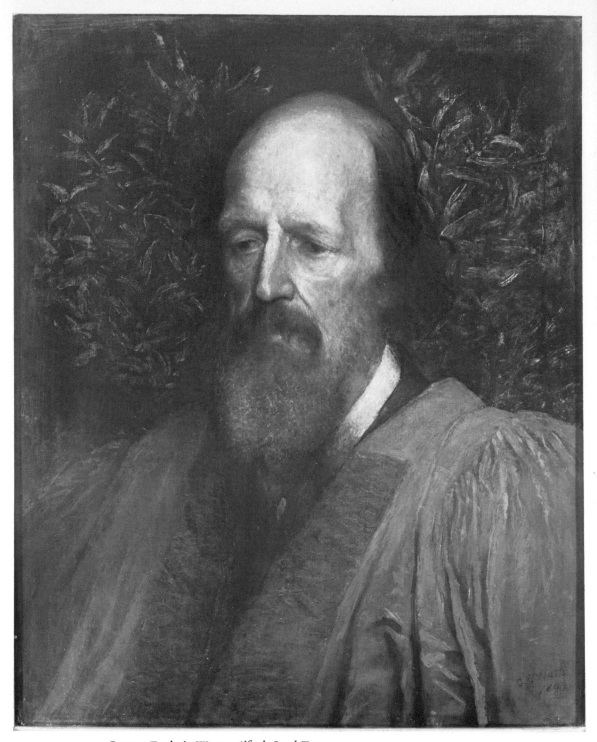

22 George Frederic Watts, *Alfred, Lord Tennyson*

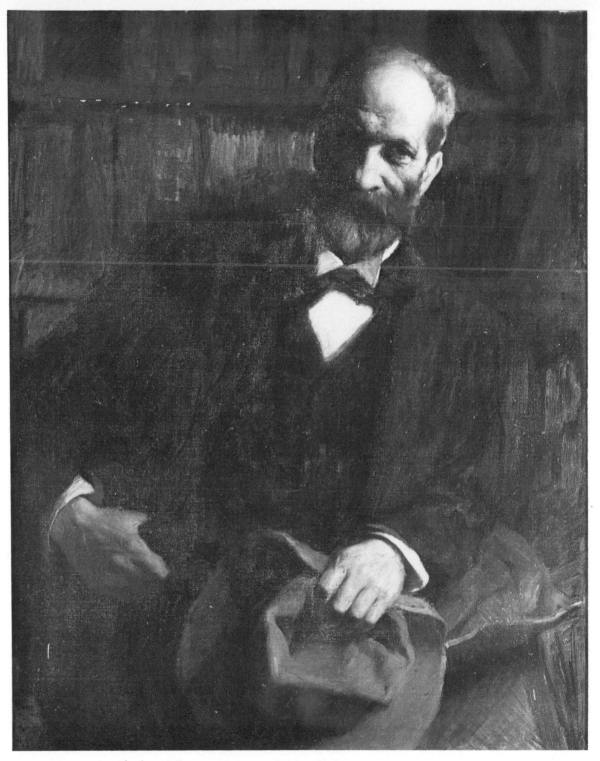

23 Charles Wellington Furse, *Frederick Whitting*

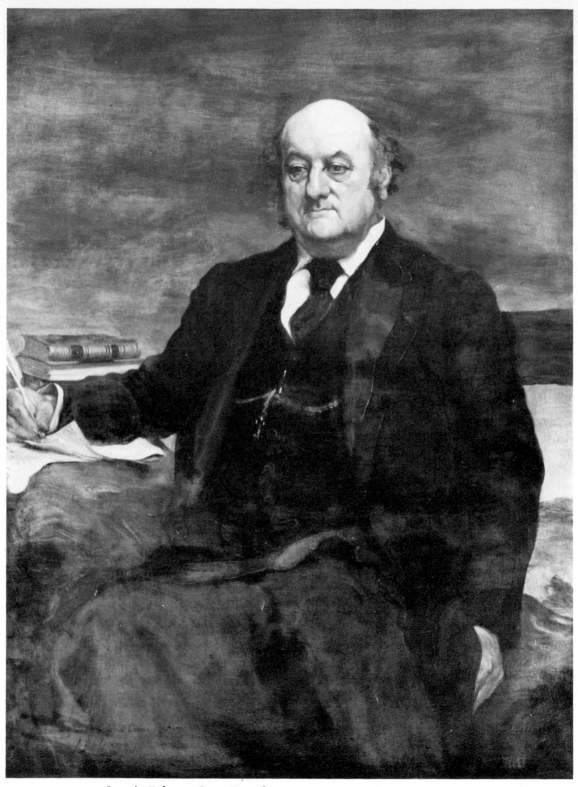

24 Ignazio Zuloaga, *Oscar Browning*

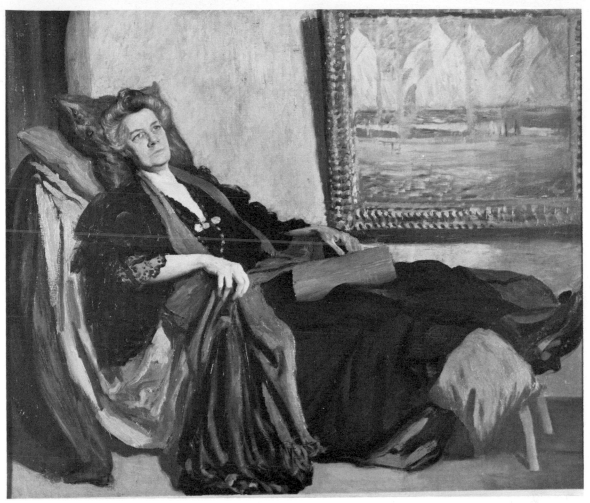

25 Augustus Edwin John, *Jane Ellen Harrison*

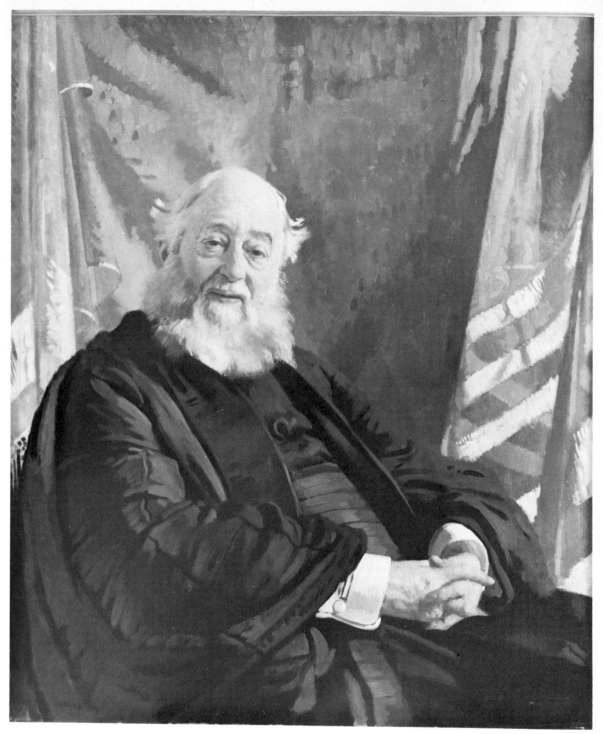

26 Sir William Newenham Montague Orpen, *Henry Montagu Butler*

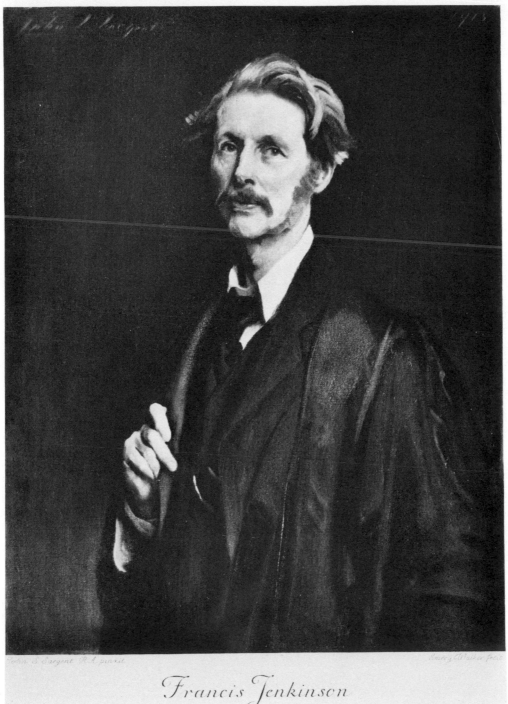

Francis Jenkinson
Librarian of Cambridge University

27 John Singer Sargent, *Francis Henry John Jenkinson*

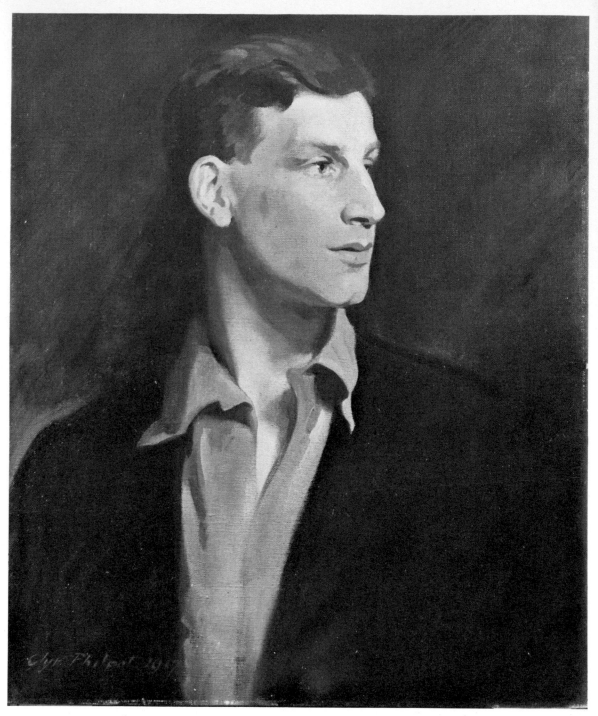

28 Glyn Warren Philpot, *Siegfried Sassoon*

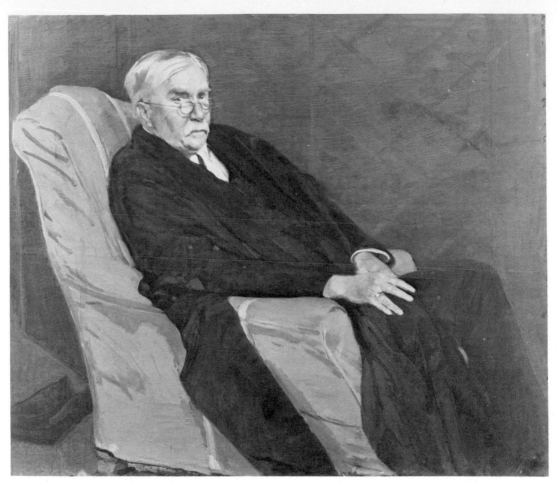

29 Sir William Newzam Prior Nicholson, *Arthur Christopher Benson*

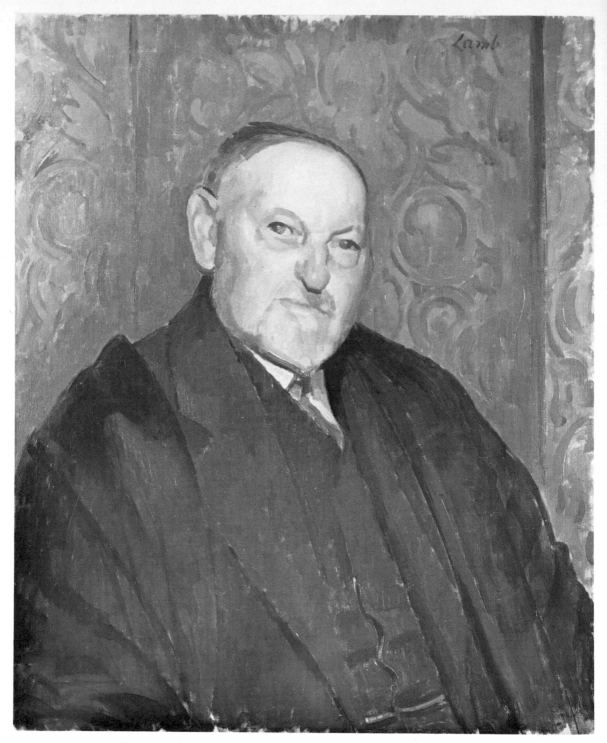

30 Henry Lamb, *William Loudon Mollison*

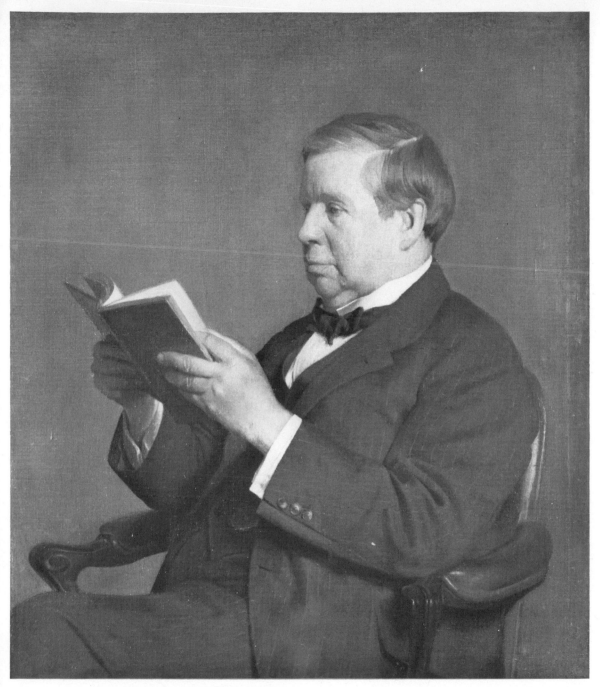

31 Sir Gerald Kelly, *Charles Whibley*

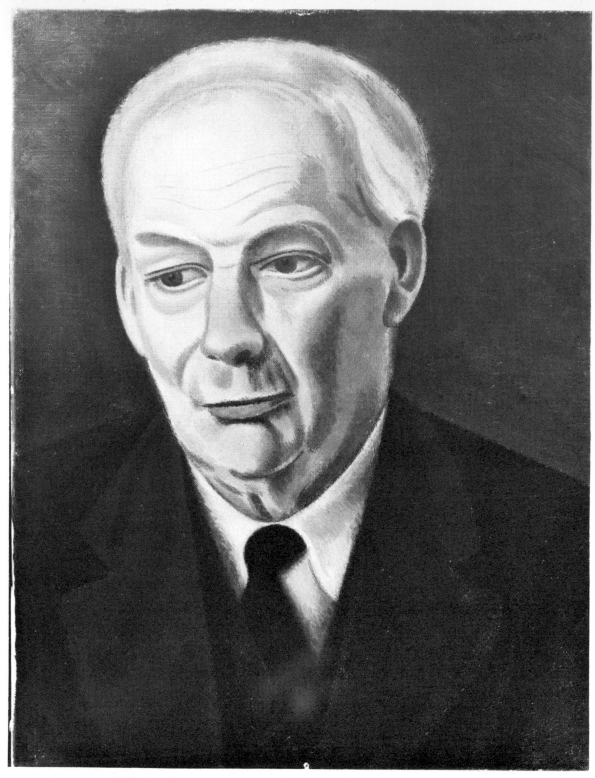

32 William Roberts, *Richard McGillivray Dawkins*

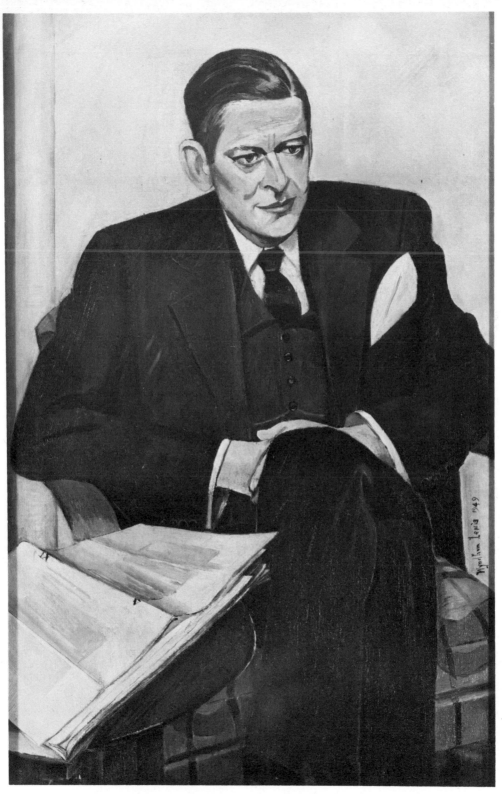

33 Percy Wyndham Lewis, *Thomas Stearns Eliot*

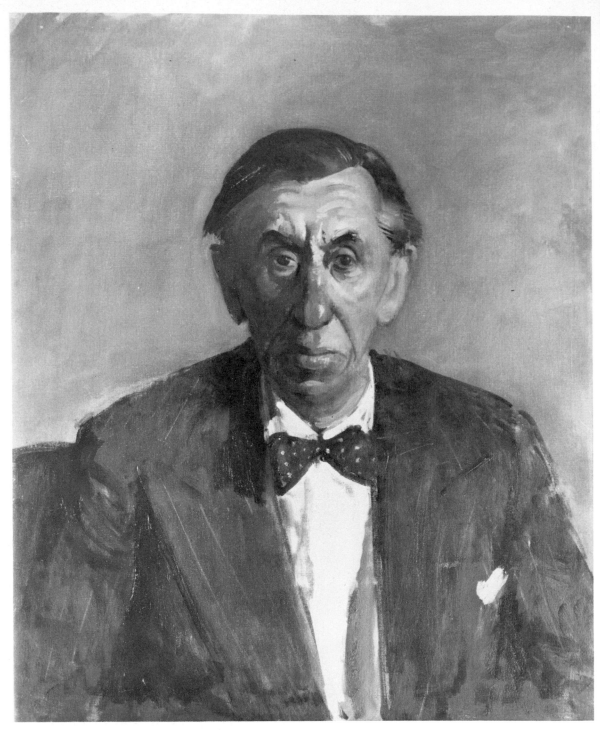

34 Ruskin Spear, *Paul Cairn Vellacott*

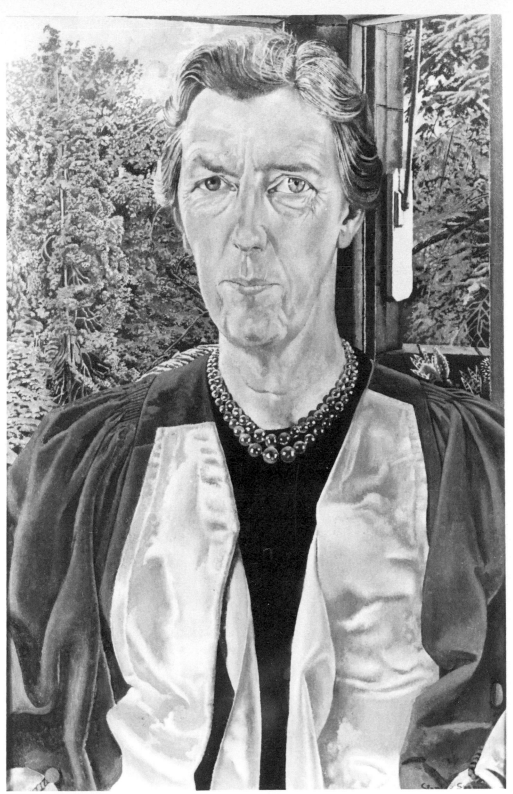

35 Sir Stanley Spencer, *Dame Mary Lucy Cartwright*

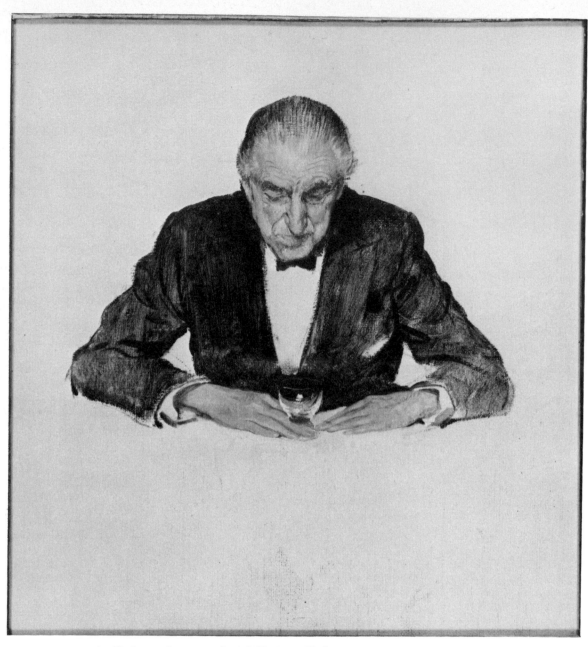

36 Sir James Gunn, *Louis Colville Gray Clarke*

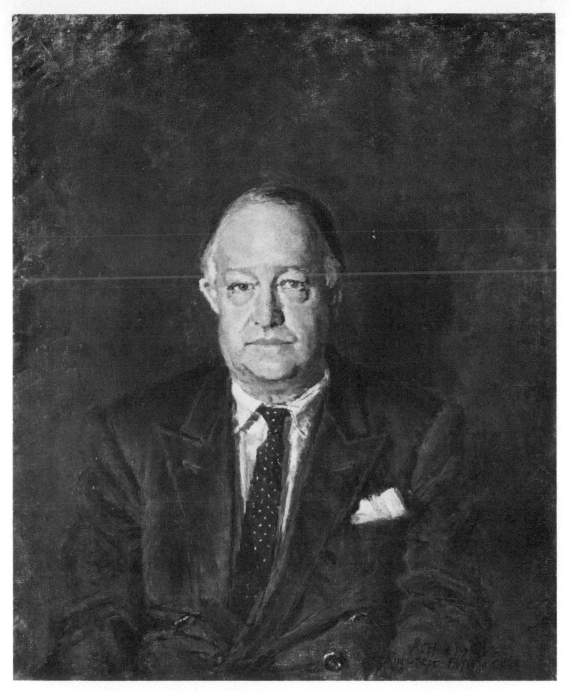

37 Allan Gwynne-Jones, *Richard Austen Butler, Baron Butler of Saffron Walden*

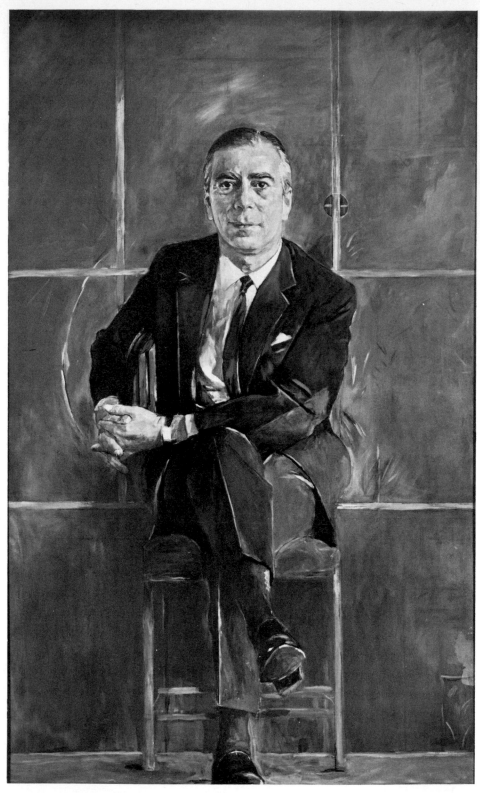

38 Graham Sutherland, *Lord Rayne*

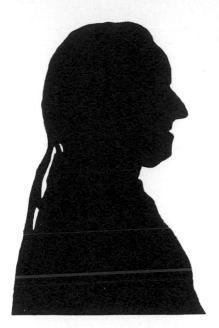

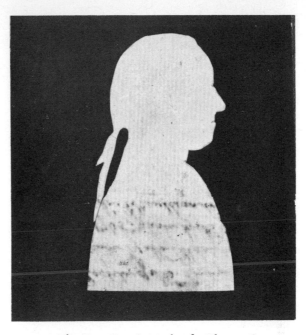

39 The Rev. Francis Mapletoft, *Thomas Gray*

40 The Rev. Francis Mapletoft, *Thomas Gray*

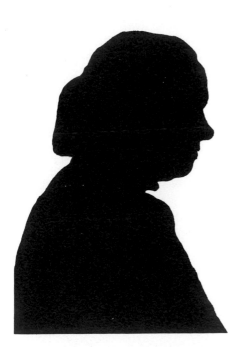

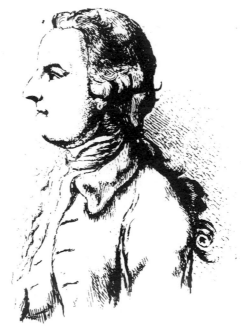

41 The Rev. Francis Mapletoft, *The Rev. William Mason*

42 William Mason, *Thomas Gray*

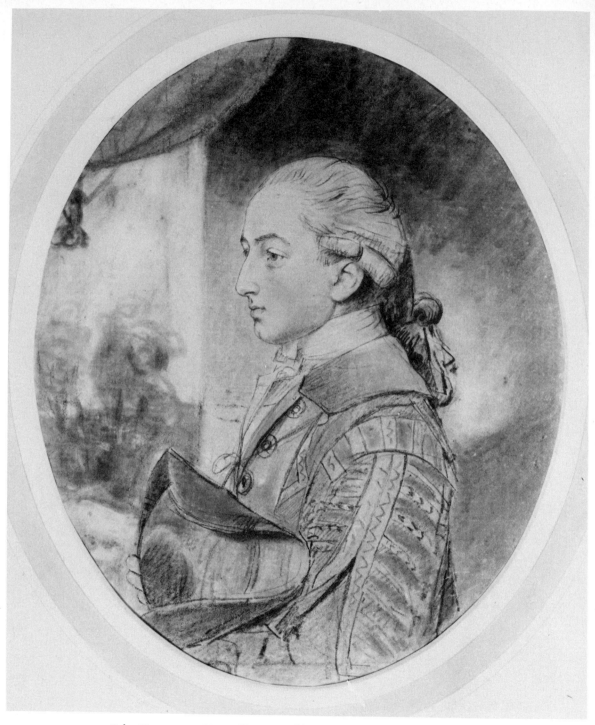

43 John Downman, *Henry Simpson Bridgeman*

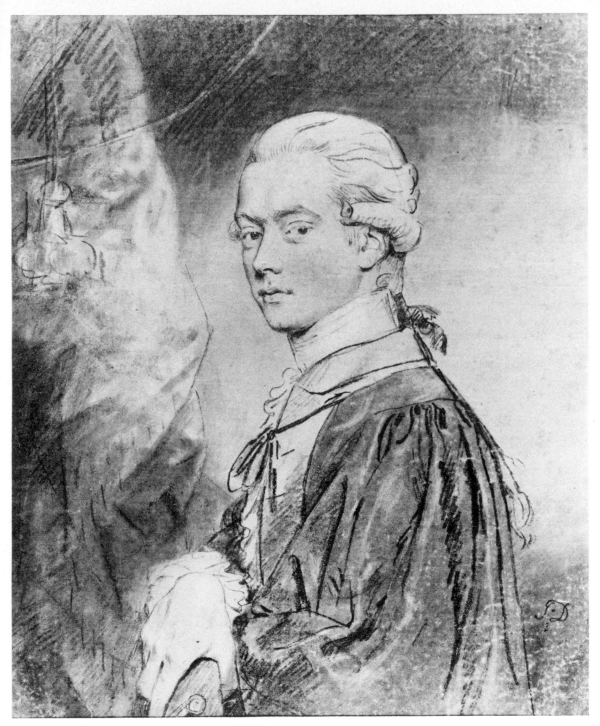

44 John Downman, *George John Spencer, Viscount Althorp*

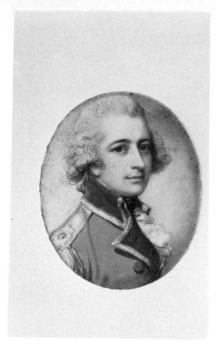

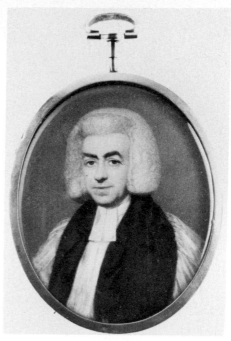

45 Richard Cosway, *Captain the Hon.*
 Edmund Phipps

46 Henry Edridge, *Samuel Hallifax,*
 Bishop of Gloucester

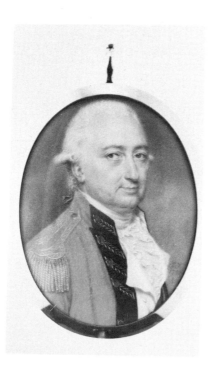

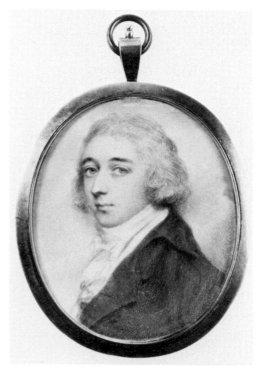

47 John Smart, *Charles, 1st Marquess*
 Cornwallis

48 Andrew Plimer, *Sir Brooke Boothby, Bart*

49 Jean Auguste Dominique Ingres, *Henry George Wandesforde Comber with Mr and Mrs Joseph Woodhead*

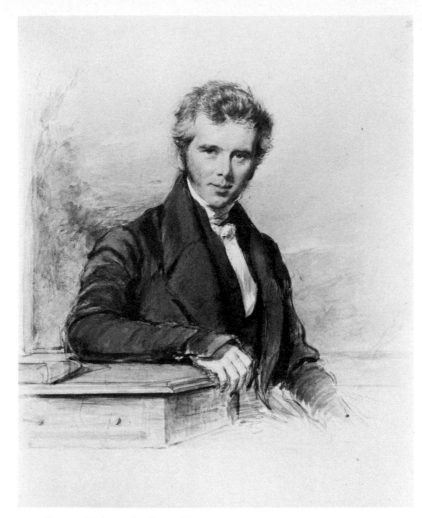

51 George Richmond, *Henry Venn*

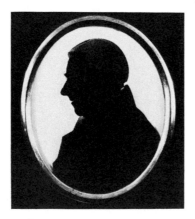

50 J. Pelham, *The Rev. Joseph Turner*

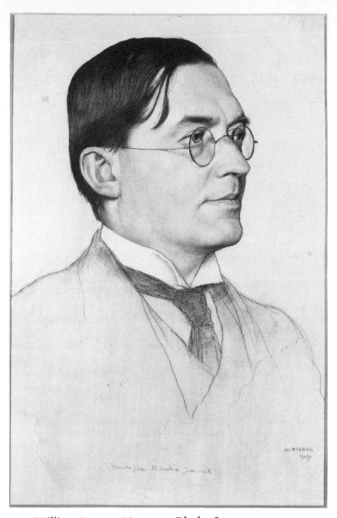

53 William Strang, *Montague Rhodes James*

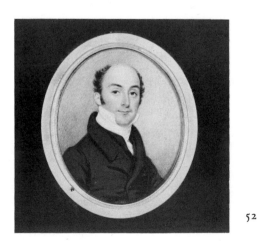

52 Unknown artist, *George
Archdall-Gratwicke*

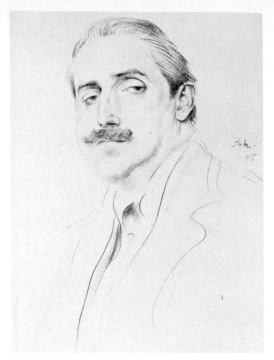

54 Augustus Edwin John, *Louis Colville
Gray Clarke*

55 William Rothenstein, *Henry
Montagu Butler*

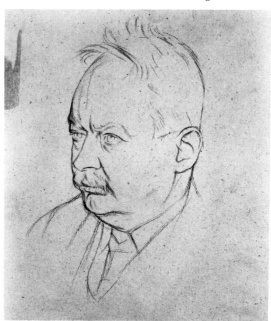

56 William Rothenstein, *John McTaggart Ellis McTaggart*

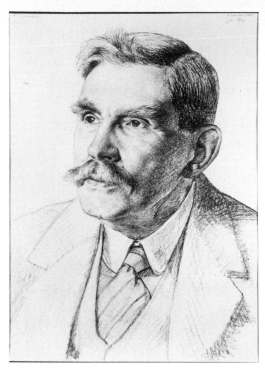

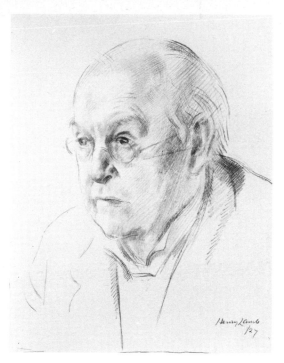

57 Francis Dodd, *James Whitbread Lee Glaisher*

58 Henry Lamb, *Sir Horace Lamb*

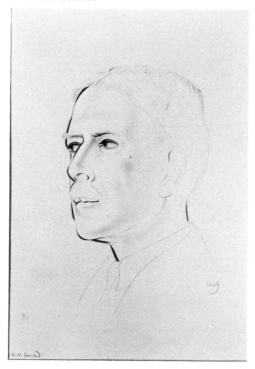

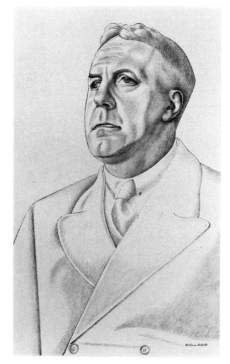

59 Eric Gill, *Francis Macdonald Cornford*

60 William Roberts, *Professor Frederick James Dykes*

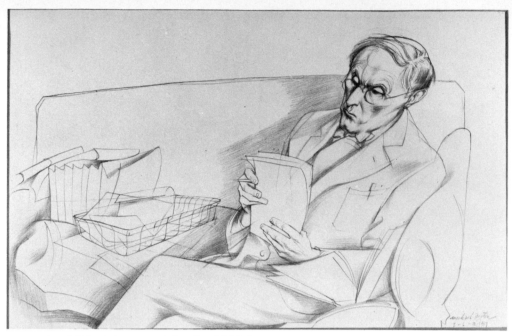

61 Michael Ayrton, *Arthur David Waley*

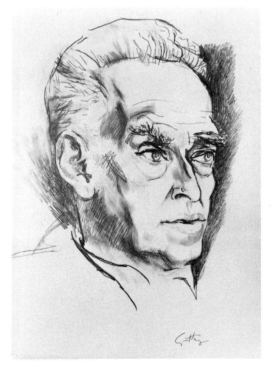

62 Renato Guttuso, *Piero Sraffa*

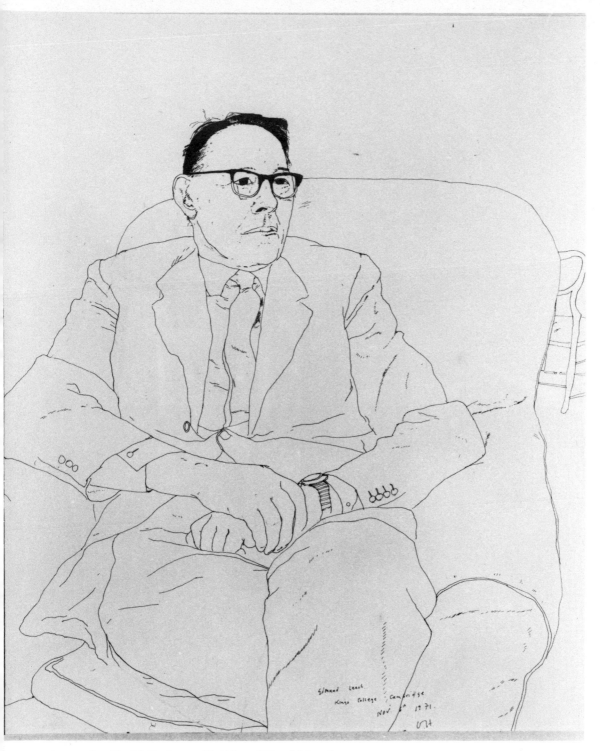

63　David Hockney, *Sir Edmund Ronald Leach*

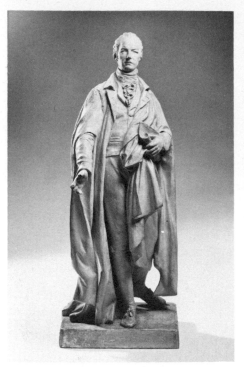

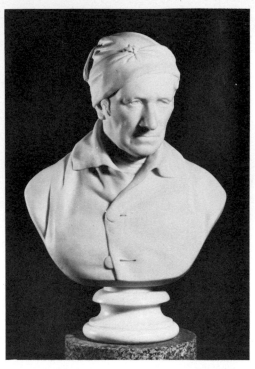

64 Joseph Nollekens, *The Hon.*
 William Pitt

65 Sir Francis Chantrey, *John Horne Tooke*

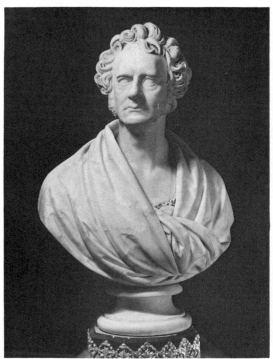

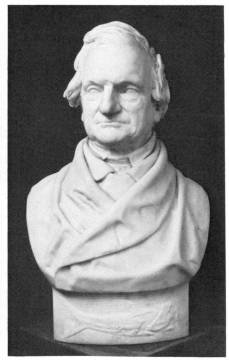

66 Edward Hodges Baily, *Sir John Herschel*

67 Thomas Woolner, *The Rev. Adam*
 Sedgwick

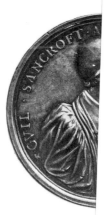

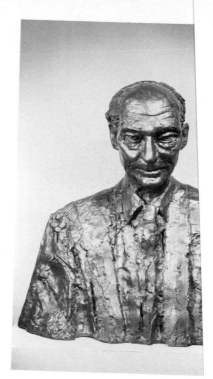

72 Sir Jacob Epstein, *Sir James Gra*

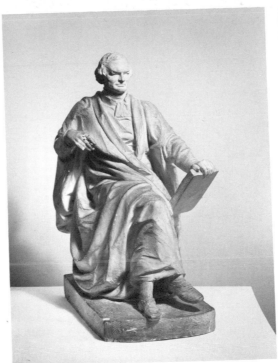

68 Thomas Woolner, *William Whewell*

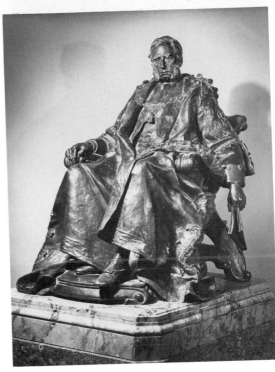

69 Sir William Goscombe John,
William Cavendish, 7th Duke of Devonshire

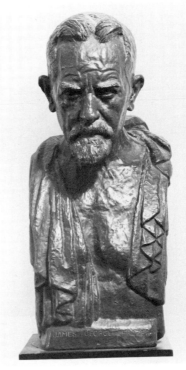

70 Emile-Antoine Bourdelle, *Sir James George Frazer*

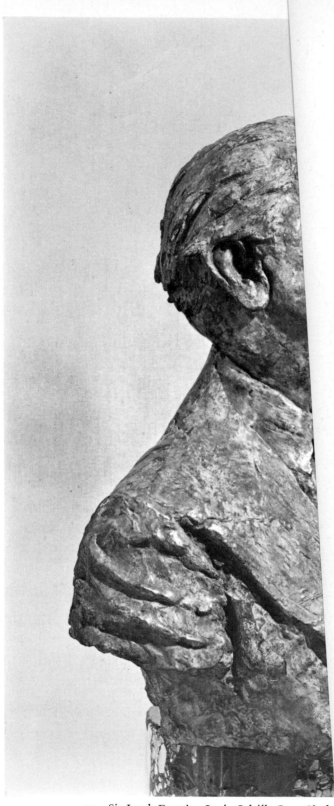

71 Sir Jacob Epstein, *Louis Colville Gray Clarke*

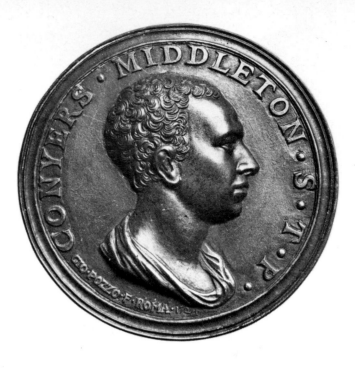

79 Giovanni Battista Pozzo, *Conyers Middleton*

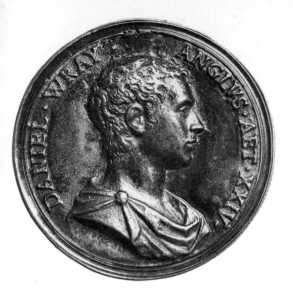
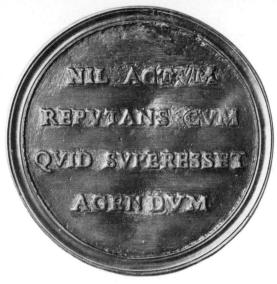

80 Giovanni Battista Pozzo, *Daniel Wray*

81 Jean Dassier, *Sir Isaac Newton*

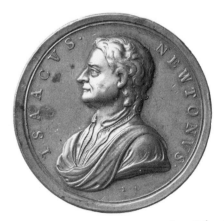

82 John Croker, *Sir Isaac Newton*

83 J. A. Dassier, *Philip Dormer Stanhope, 4th Earl of Chesterfield*

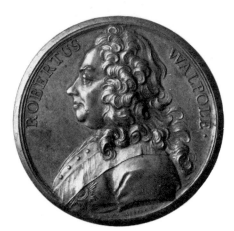

84 J. A. Dassier, *Robert Walpole, Earl of Orford*

85 Anonymous medallist, *Martin Folkes*

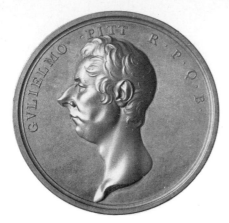
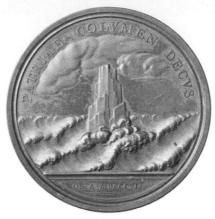

86 Thomas Webb, *The Hon. William Pitt*

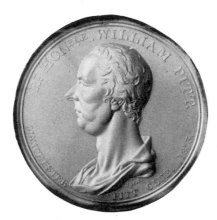
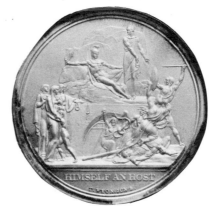

87 Thomas Wyon, Jr, *The Hon. William Pitt*

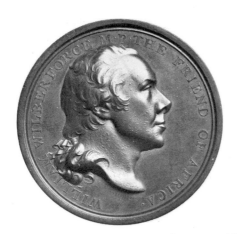
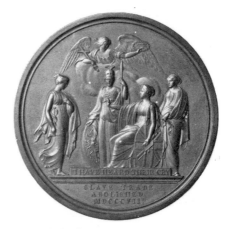

88 Thomas Webb, *William Wilberforce*

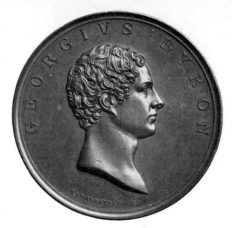

89 Gaspare Galeazzi, of Turin, *George Gordon, Lord Byron*

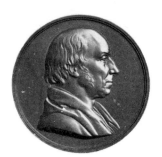

90 L. C. Wyon, *William Wordsworth*

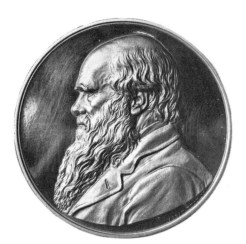
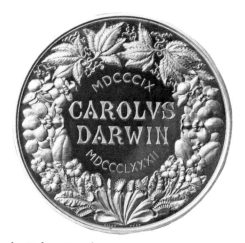

91 Allen Wyon, *Charles Robert Darwin*

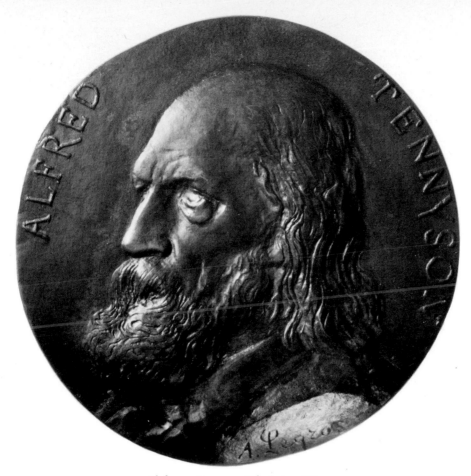

92 Alphonse Legros, *Alfred, Lord Tennyson*

93 G. W. de Saulles, *Sir George Gabriel Stokes*

94 Percy Metcalfe, *William Whitehead Watts*

INDEX OF ARTISTS

References are to catalogue numbers

INDEX OF SITTERS

References are to catalogue numbers